THE FUNDAMENTALS OF
DRAWING ANIMALS

THE FUNDAMENTALS OF
DRAWING
ANIMALS

A STEP-BY-STEP GUIDE TO CREATING EYE-CATCHING ARTWORK

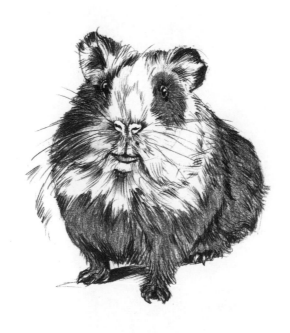

DUNCAN SMITH

ARCTURUS

About the author

Duncan Smith started drawing when he was a small child and hasn't stopped since. Since graduating with Honours from the Glasgow School of Art over 20 years ago, he has worked as a freelance illustrator for many high-profile clients. He has written and illustrated his own children's books, worked as a concept artist in the film industry and taught drawing classes to adults and children. Duncan lives in London with his wife Nina, his daughter Deepy, two cats and two wee dogs, Ted and Buffy.

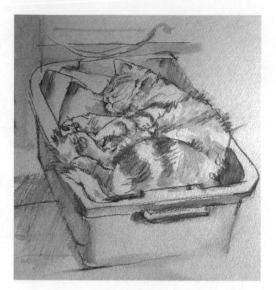

Dedication

This book is dedicated to my wife, who has more faith in me than I do, and to our cat Shuggie, who kept me company during the long nights when I did most of the drawings for this book. Unfortunately he couldn't hang around to see the finished book, but we were blessed with the time that he spent with us.

ARCTURUS

This edition published in 2013 by Arcturus Publishing Limited
26/27 Bickels Yard, 151–153 Bermondsey Street,
London SE1 3HA

ISBN: 978-1-84858-578-2
AD001143EN

Printed in China

Contents

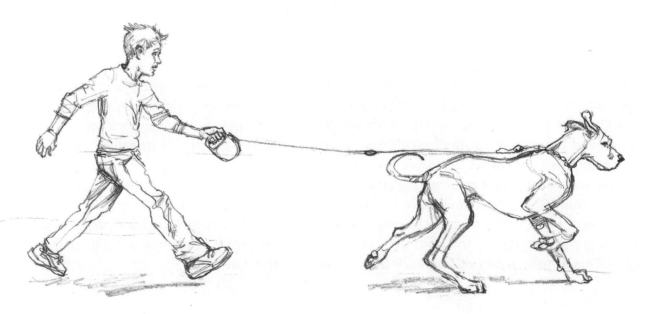

Introduction

When we were young, we would draw without hesitation or thought. 'Draw me a dog,' someone would say, and off we'd go and scribble away quite happily in a corner. A short time later we'd be back, announcing, 'This is the best drawing of a dog in the world, and can we put it on the wall now?' For when we were young we had no fear of drawing and there wasn't anything we couldn't draw.

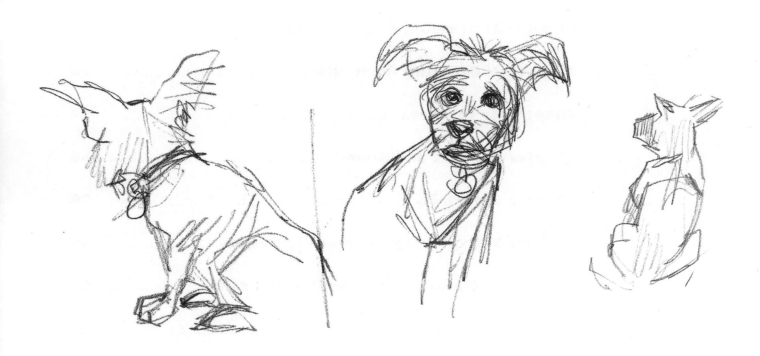

Some people retain this ability into adulthood, and even manage to make a living out of it! However, most become too self-conscious once early childhood is past and simply give up after hearing one negative comment, their confidence destroyed. The classic line I often hear when people discover I'm an artist is, 'Oh, I wish I could draw.' Well, I'm here to tell you that **you can**! You've made the first step by buying this book. Drawing isn't a mystery – you don't need to have any special equipment, wear outlandish clothes, or look 'artistic' while drawing your subjects. You just need some paper, pencils and patience.

I know from my experience of teaching drawing classes and private students that everyone wants to just dive in and start drawing, but there are basic things you need to know. I've kept all the complicated anatomy and structure of animals to a minimum; if you need to go into this in depth at a later stage there are plenty of text books out there that will cover it in more detail.

While the anatomy of any type of animal can be learned, trying to capture the character of a particular model is the tricky part, and if you're drawing from life you have to be quick. Animals don't stay still for long enough for you to do a finished piece, so use this time to practise quick sketches. This will allow you to be free with your technique and line, and you can use your sketches later for more finished work. When you want to do really detailed drawings, photographs are a great boon.

In this book I've tried to give you a step-by-step guide to drawing your pets and other animals. By following the demonstrations and putting into practice the tips and shortcuts you'll find dotted throughout the book, you should achieve a set of drawings of a standard that may surprise you. This, I hope, will inspire you to continue on your journey to become an even better artist, taking creative chances and finding the style of drawing that suits you best.

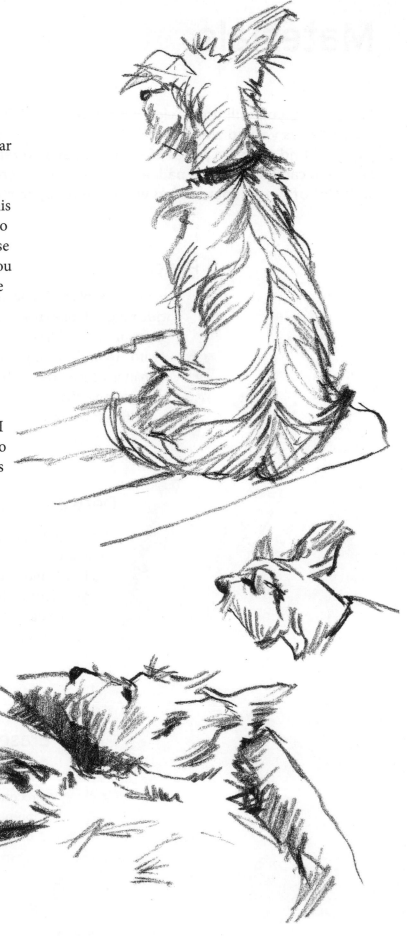

Materials

As an artist, you will use a wide variety of materials and discover your particular favourites as you go along. Here I have listed some of the materials in my studio (you will find more on pages 86–103), but all you really need at first are some good pencils, a cartridge sketch pad, a putty rubber, a pencil sharpener, a little imagination and a lot of determination and you're all ready to start your adventure!

Pencils

I use only B (black) grade pencils, as they are soft and you can easily achieve a wide range of tones from pale grey to jet black by varying the weight you place on your pencil. I favour a 3B pencil, and it's the one I start most drawings with. To find which you prefer, buy them in the range 2B to 8B (it doesn't matter which brand). The H (hard) grade pencils are more for technical drawing – they are very hard pencils and the marks they make are difficult to erase.

Derwent watersoluble sketching pencils

I use these a lot, as they are lovely pencils to sketch with. They work like watercolour – all you have to do is apply a wash of water with a brush and you can create wonderful tones in a very short time. After letting the washes dry you can apply more pencil lines to create darker tones, and with a little practice you'll be able to create quite finished detail work.

Eraser

There are many erasers on the market, and of these I recommend a putty rubber. It can be moulded into a nice point to remove just the fine lines you need erased, and unlike other erasers it leaves no debris behind.

Watersoluble brush pens

These are my choice for creating finished ink drawings. They are basically felt-tip pens, except that they have a proper brush at the end of the tip instead of a nib. You can make beautiful fine or thick lines and vary the line weight, just as with a regular brush, then, once you have inked up your drawing, you can paint into the image using a brush and water to create softer tones and washes. By working carefully and letting the washes dry between applications, it's possible to quickly build up a three-dimensional drawing.

Pencil sharpener or craft knife

I use a good pencil sharpener or a craft knife to make my pencils nice and pointy. It's easy to get so engrossed in your drawing that you don't notice that your pencils are becoming blunt, so you should aim to establish the habit of keeping your pencils as sharp as you can while you work.

Paper

Any good cartridge paper or pad will do for your purposes at first, though if you want to have a go at the illustrations here that use washes, it's best to use heavyweight (220gsm/100lb) cartridge paper. Layout paper is handy, as it will let you trace over your drawings to redo them or trace the finished drawings in this book. Later, when you feel more confident in your drawing skills, you can explore all the different types of paper suitable for drawing – watercolour paper for very heavy washes, Ingres paper for heavy pastel work and marker pads for any drawings with markers and fine pen work.

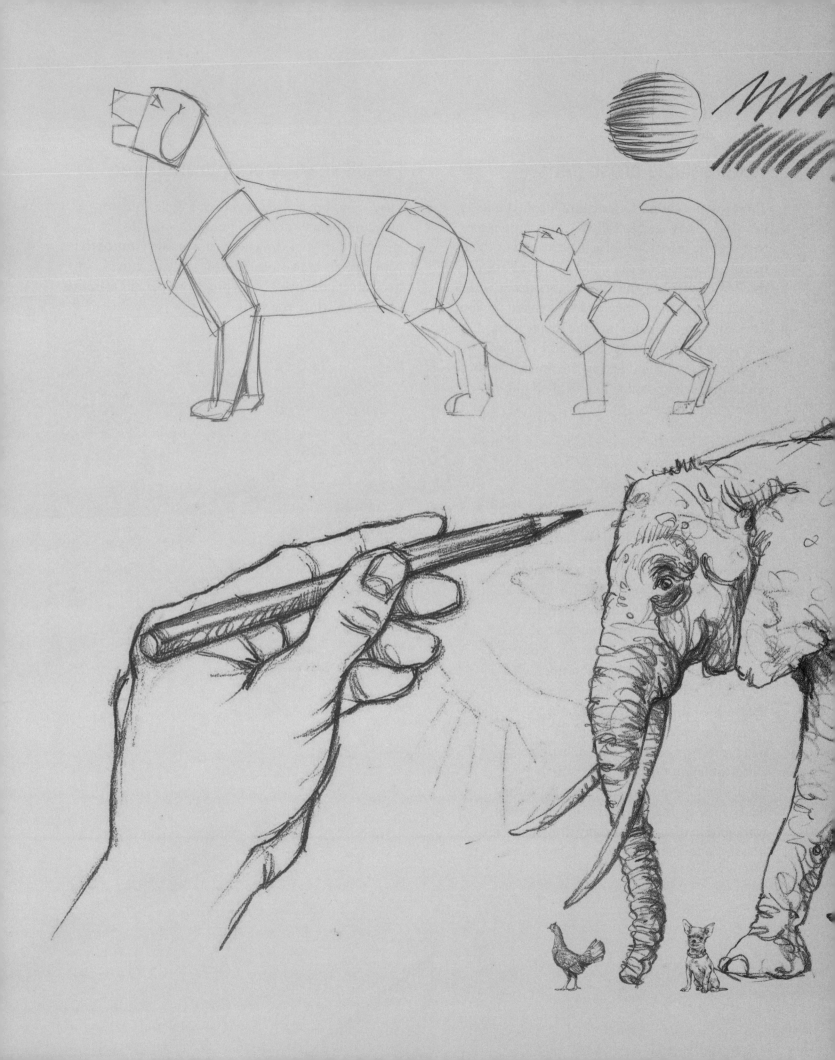

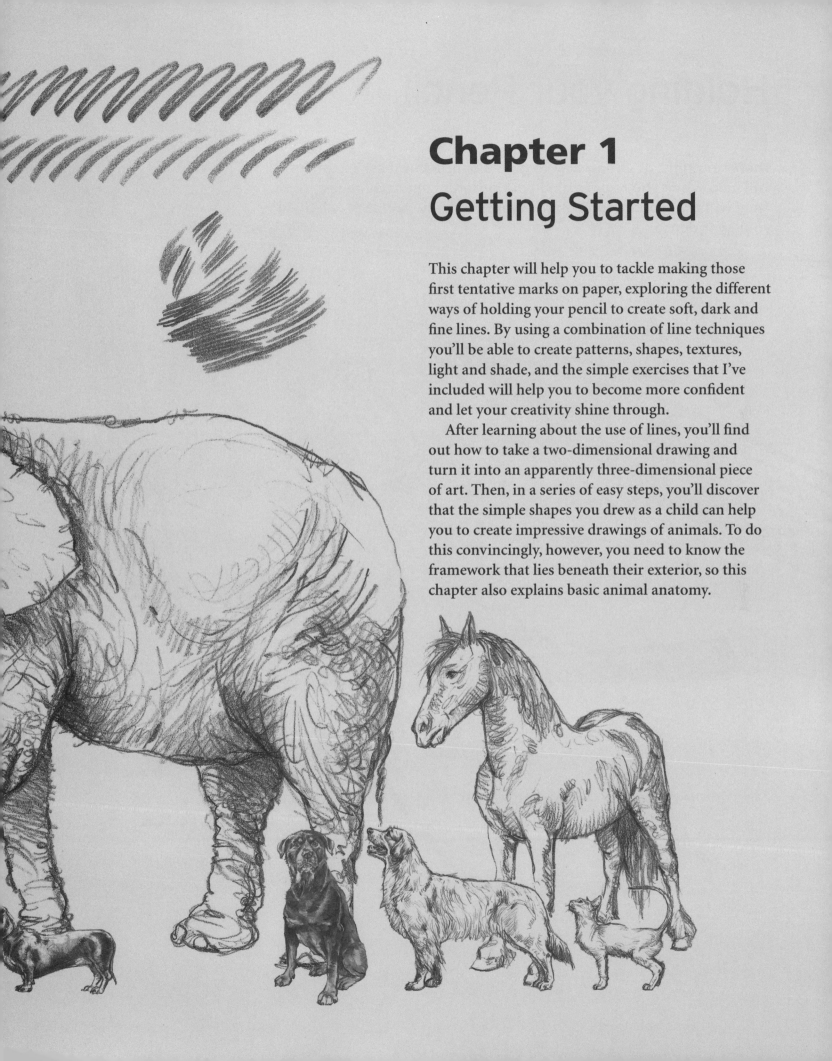

Chapter 1
Getting Started

This chapter will help you to tackle making those first tentative marks on paper, exploring the different ways of holding your pencil to create soft, dark and fine lines. By using a combination of line techniques you'll be able to create patterns, shapes, textures, light and shade, and the simple exercises that I've included will help you to become more confident and let your creativity shine through.

After learning about the use of lines, you'll find out how to take a two-dimensional drawing and turn it into an apparently three-dimensional piece of art. Then, in a series of easy steps, you'll discover that the simple shapes you drew as a child can help you to create impressive drawings of animals. To do this convincingly, however, you need to know the framework that lies beneath their exterior, so this chapter also explains basic animal anatomy.

Holding your Pencil

There's no right or wrong way to hold a pencil, but these examples
will help when you're practising your different line techniques.
They will give you freedom in the ways you draw and that will build
your confidence.

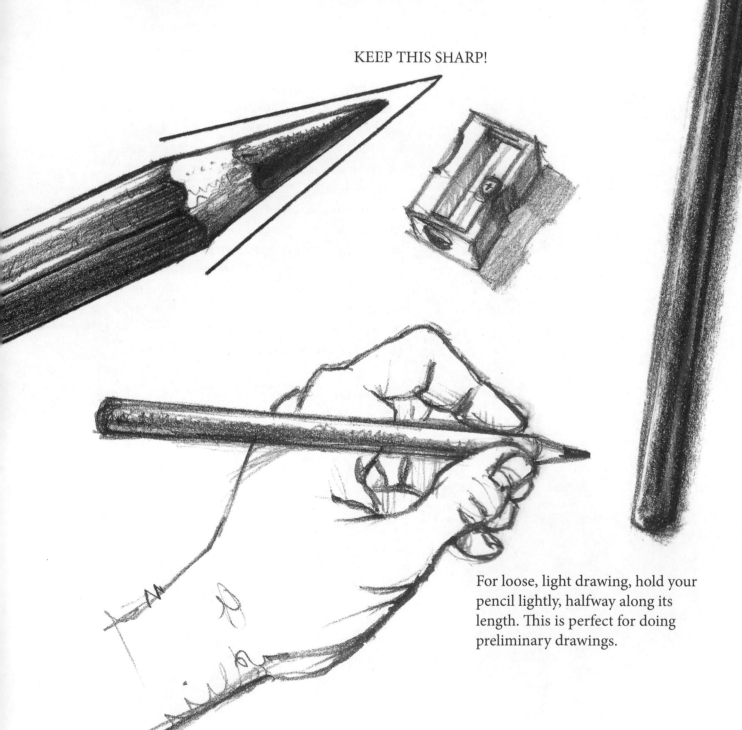

KEEP THIS SHARP!

For loose, light drawing, hold your
pencil lightly, halfway along its
length. This is perfect for doing
preliminary drawings.

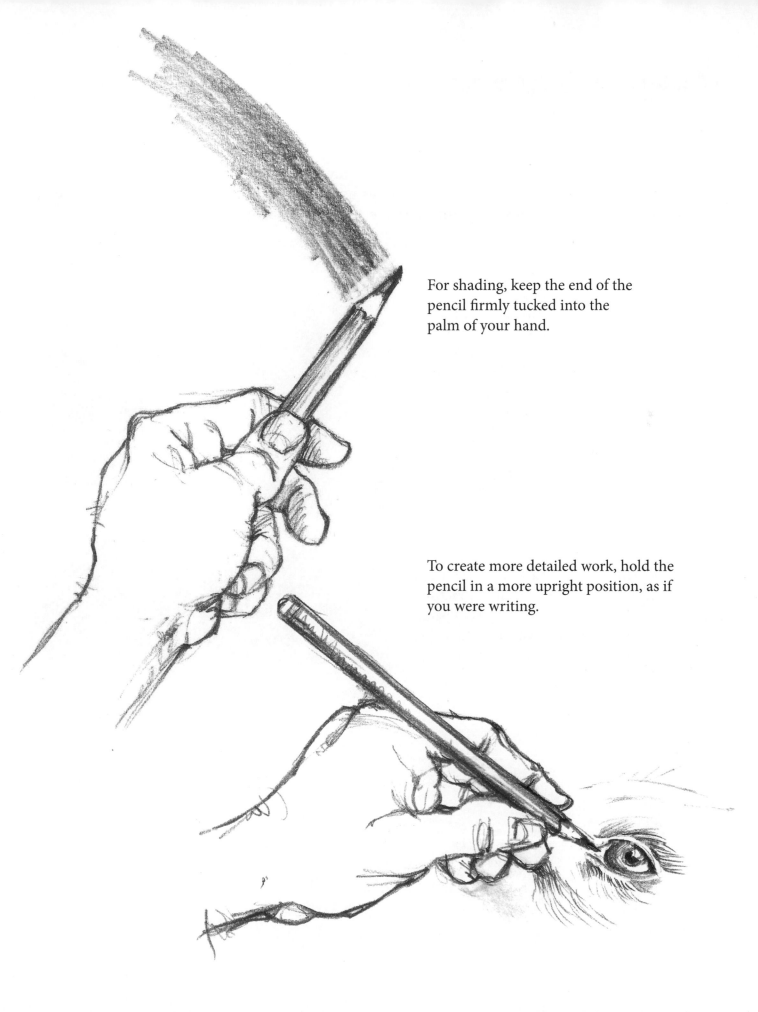

For shading, keep the end of the pencil firmly tucked into the palm of your hand.

To create more detailed work, hold the pencil in a more upright position, as if you were writing.

Making a Mark

Putting pencil to a blank piece of paper can be quite daunting, but be brave and make the first mark – you can always use your eraser, after all! Here are some examples of different line techniques to try.

Contour lines are used to define the outline of an object. You can also draw more complex contour lines across the surface of an object to help create its form.

'Tone' refers to the light and dark areas on an object, which are dictated by your light source. Practise creating tone or pattern by drawing a set of parallel lines then crossing over them with another set (see right). This is called cross-hatching.

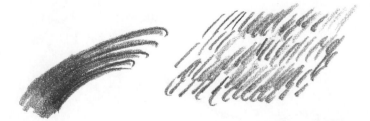

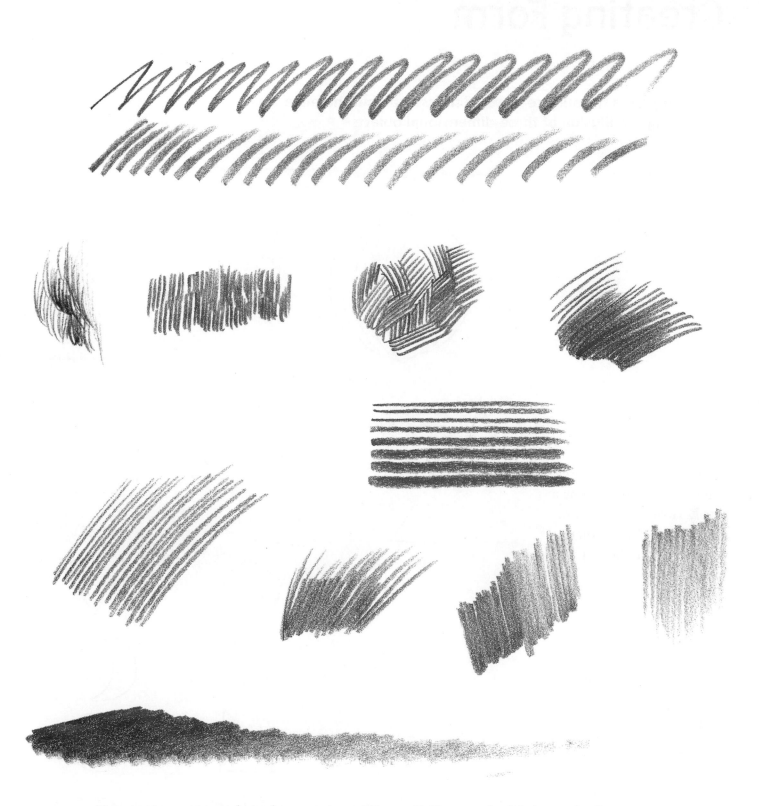

Now try to create graduated tone, using a 5B pencil. You can do this by gradually reducing the pressure on your pencil as you draw from heavy to light. Practise making marks and varying the amount of pressure you apply to see the effects you can achieve.

Creating Form

A drawing on a flat surface is two-dimensional, but there are ways of creating the illusion of three-dimensional objects.

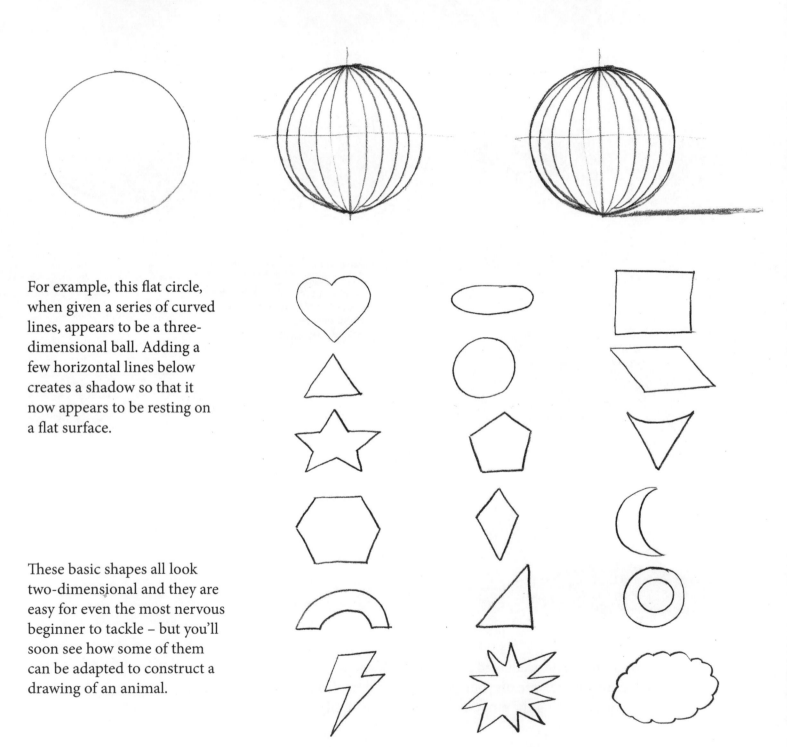

For example, this flat circle, when given a series of curved lines, appears to be a three-dimensional ball. Adding a few horizontal lines below creates a shadow so that it now appears to be resting on a flat surface.

These basic shapes all look two-dimensional and they are easy for even the most nervous beginner to tackle – but you'll soon see how some of them can be adapted to construct a drawing of an animal.

Drawing a fish

In this simple exercise you'll discover how to create an apparently three-dimensional fish from a two-dimensional drawing.

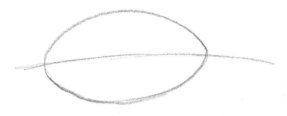

1 First, draw an oval and then a guideline through the middle.

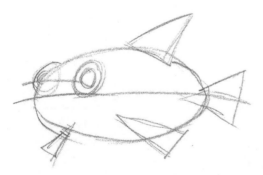

2 Next, add triangle shapes for the fins and tail and some more ovals for the eyes.

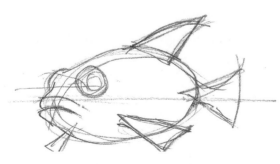

3 Below the guideline at the front, add a couple of downward lines to look like the fish's mouth.

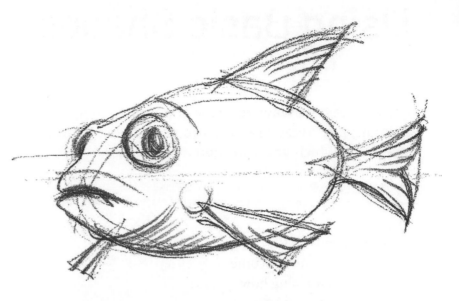

4 Darken the oval eyes and add pupils, then make the fins look more realistic by drawing slightly curved lines coming towards the fish's body. Add some tone to the underside of the fish by drawing contour lines that follow the shape of its belly.

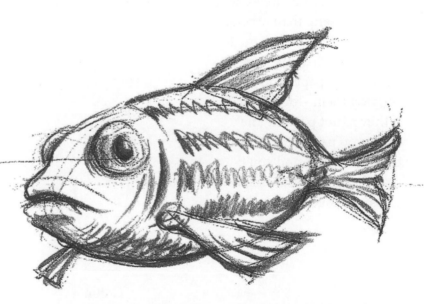

5 Make the lines of the mouth and the fish's outline stronger, using a darker tone. Add some wavy lines to create the pattern of the fish, which will also help to give it shape and weight. Finally, add some more darker lines to the underside to create the illusion of shadow.

Using Basic Shapes

One of the best ways to draw apparently complicated images of animals, and indeed people too, is to break them down into basic shapes to which you can then add detail.

There are plenty of shortcuts that will help you to become an artist, and learning how to draw such shapes is one of them.

I've drawn some shapes here that will help you when you try some of the exercises in the book. Some of them, such as ovals and circles, will be more useful than others, but it's worth having a go at all of them. So, grab some pencils and paper and start copying them – don't worry if they're not perfect. The more you practise the easier they'll become, and you'll soon be able to draw them without hesitation.

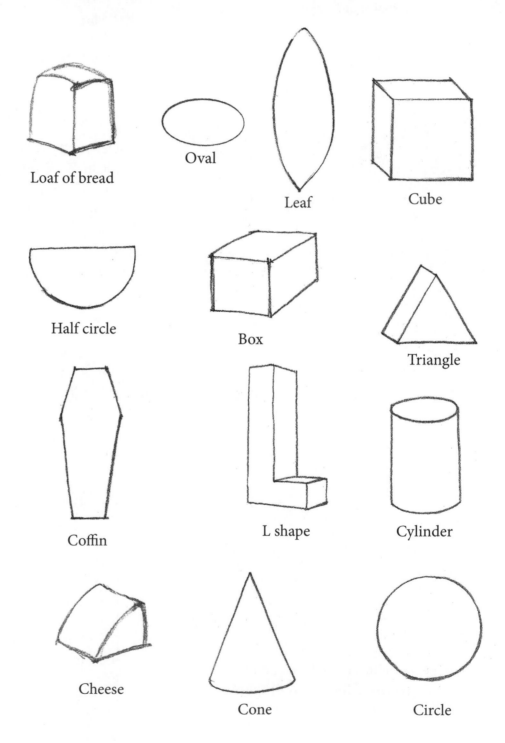

Loaf of bread

Oval

Leaf

Cube

Half circle

Box

Triangle

Coffin

L shape

Cylinder

Cheese

Cone

Circle

Now you've had a chance to draw some shapes, let's try drawing a dog's head, following the steps shown here. You'll be surprised at how quickly it comes together.

1 Draw a loaf of bread shape and then add a cheese shape on to it.

2 Draw some triangles for the eyes and nose, add some roughly leaf-shaped ears and don't forget the smiley open mouth.

3 Looking at the finished sketch, start to add some of the details like the tongue, lips and pupils of the eyes.

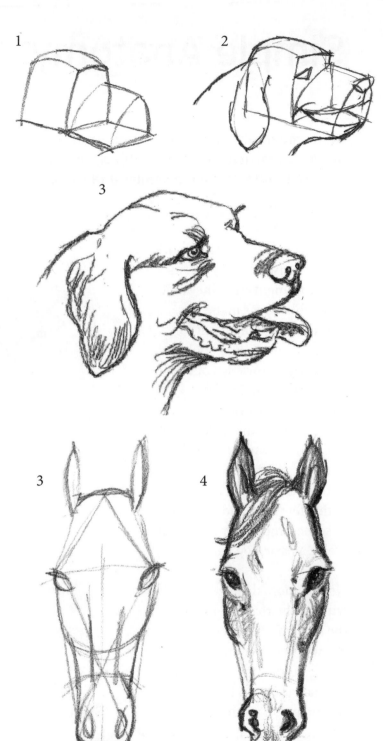

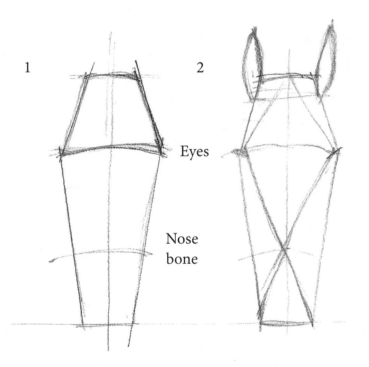

1 To draw a horse's head in the same way, first draw the coffin shape from the facing page. Roughly divide it into three parts; this will give you a guide for the position of the eyes and nose bone.

2 Add diagonal lines as shown, dividing the shape into several triangles. Add leaf shapes for the ears.

3 Roughly mark in the shape of the muzzle and cheekbones using curved lines and add more leaf shapes for the eyes, ears and nostrils. Draw two lines to suggest the projecting nose bone.

4 Take some time to add details to give your drawing a more finished look.

Simple Anatomy

Anatomy might sound daunting but it simply means the building blocks, or structure, of any subject, be it animal or human. Luckily for us, most animals have a similar anatomical structure.

The skeleton is the framework for the muscles and governs the movements that the subject is capable of. It's made up of numerous bones, but for the drawings in this book an advanced knowledge of the skeleton isn't needed.

First, here's a simple breakdown of the skeletons of a dog and cat which will help you to understand the basic structure of the animals. You can see that with a few lines and the help of some simple shapes you can create a basic dog and cat.

Next, a more detailed look with all the relevant parts of the structure labelled so you know where the joints are. Using human terms to relate the animal's skeleton to our own will help you to understand it better. At this stage it's important to take some time to copy these images and try to remember where the labelled parts are. Whether you draw from life or photographic reference you need to understand the basics, since knowing what's going on beneath the skin and muscles will give you confidence.

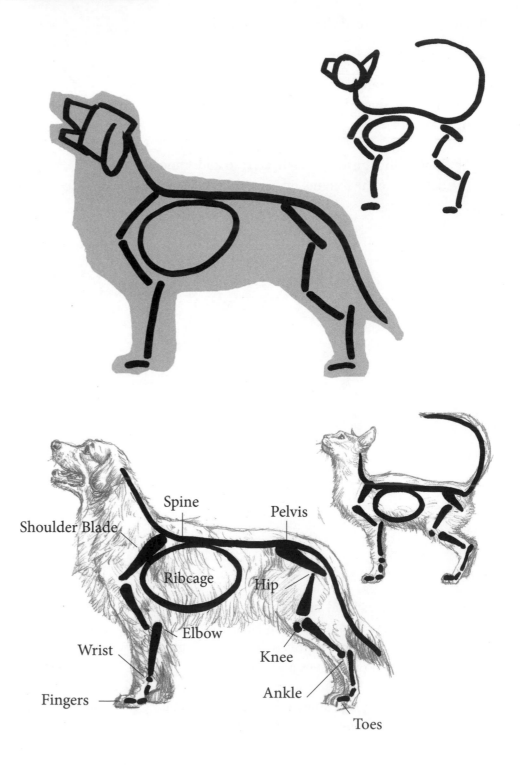

Spine

Shoulder Blade

Pelvis

Ribcage

Hip

Elbow

Wrist

Knee

Fingers

Ankle

Toes

Using these examples, try to copy the finished dog and cat drawings, using the simple line drawings you've been practising.

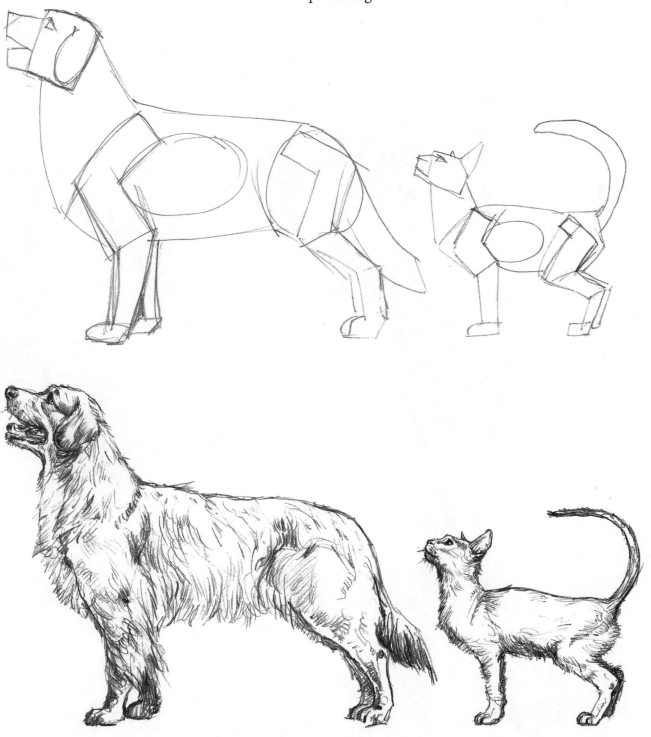

All Creatures Great and Small

Animals come in all shapes and sizes, from the humble chicken to the giant elephant.

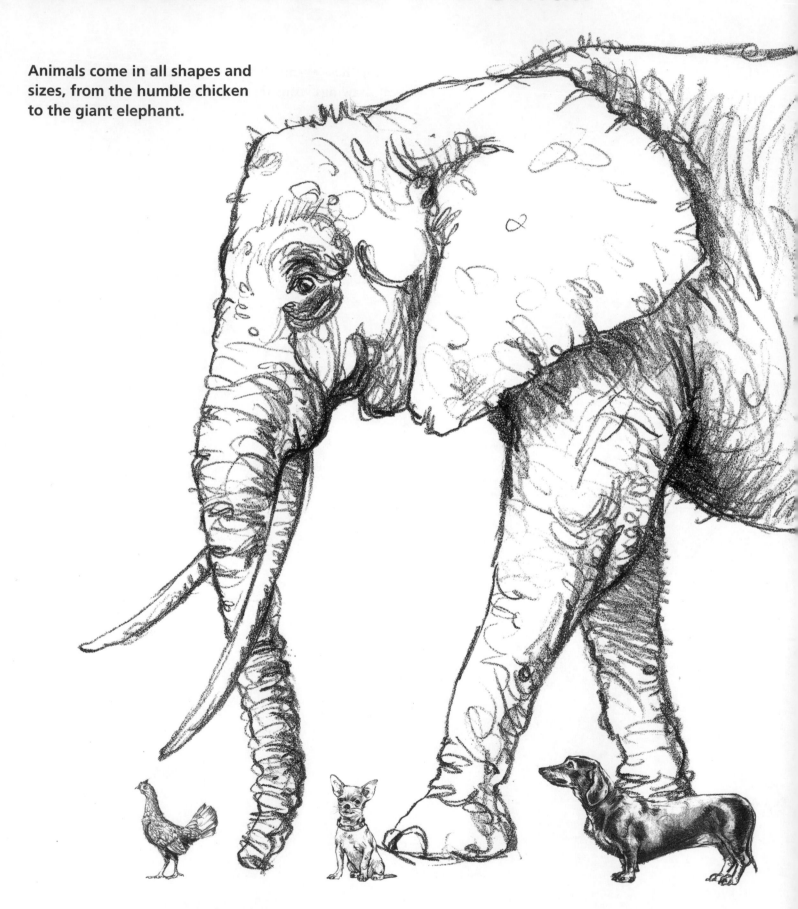

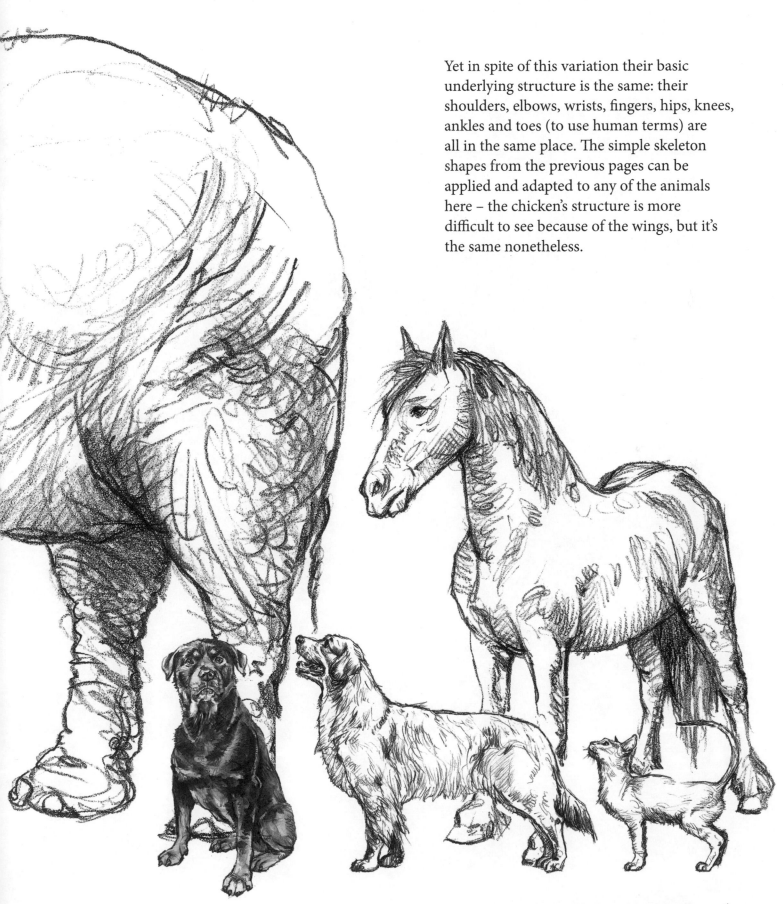

Yet in spite of this variation their basic underlying structure is the same: their shoulders, elbows, wrists, fingers, hips, knees, ankles and toes (to use human terms) are all in the same place. The simple skeleton shapes from the previous pages can be applied and adapted to any of the animals here – the chicken's structure is more difficult to see because of the wings, but it's the same nonetheless.

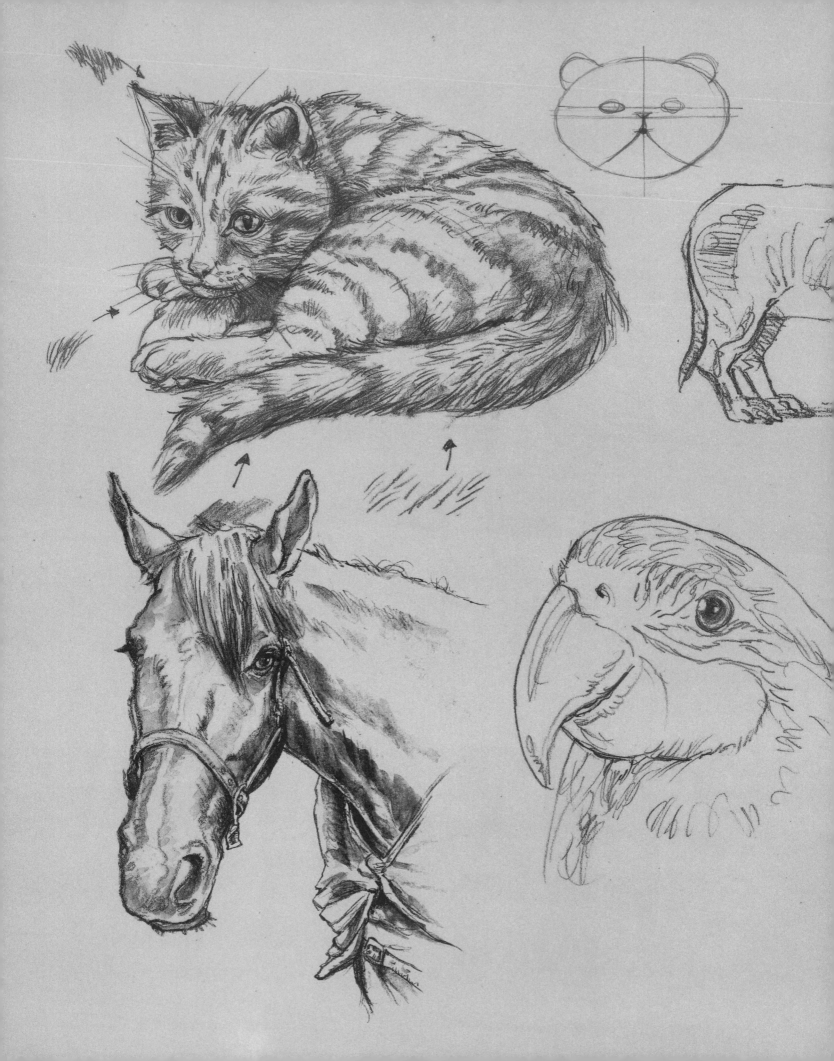

Chapter 2
Drawing
Step-by-Step

This chapter introduces you to step-by-step demonstrations where you can follow my development of a drawing. I've approached these drawings in a simple fashion, each one starting off as a basic thumbnail sketch and building up slowly in stages to a finished piece. I've also showed close-ups of the line or wash work so that you can see the techniques I've used to create that part of the drawing, be it tonal variations, fur or feathers.

When you follow these exercises, use them as a guide to let your own style of drawing shine through rather than trying to make an exact copy of my finished drawing. Have some fun drawing your own versions of the cats, dogs, parrot and horse, then when you've completed these demonstrations, find some photographs of your pets and enjoy creating new images using what you've learned. By all means draw and redraw using all the techniques I've shown you, but when you're ready you'll find your own style of drawing.

Tabby Cat Step-by-Step

This is a fairly simple drawing to start with; the pose is basically a big oval shape, so this means you can concentrate on the head and use the cat's stripey pattern to help create the shape of the body.

Materials and Equipment

- 3B and 4B pencils
- 220gsm (100lb) cartridge paper
- Putty rubber
- Pencil sharpener

Step 1

The first thing I did was to make a little thumbnail drawing of the cat and mark in where I could see the darkest tones. Half-closing your eyes will help you to see the tonal values.

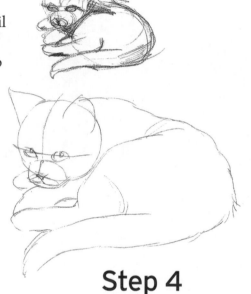

Step 2

Next I drew a quick circle for the head and an oval for the nose area, then made a loose preliminary sketch of the body, tail and legs.

Step 3

I started to erase some of the guidelines and add more detail, such as the pattern on the cat's head and back.

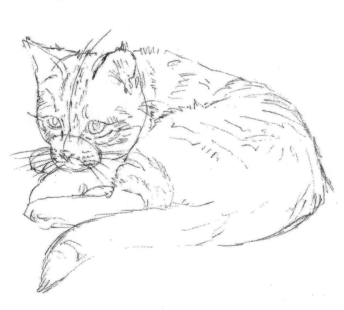

Step 4

Then I concentrated more on the head, eyes and ears, using different pencil strokes and indicating the directions in which the fur lies.

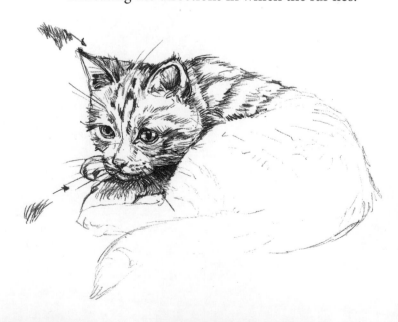

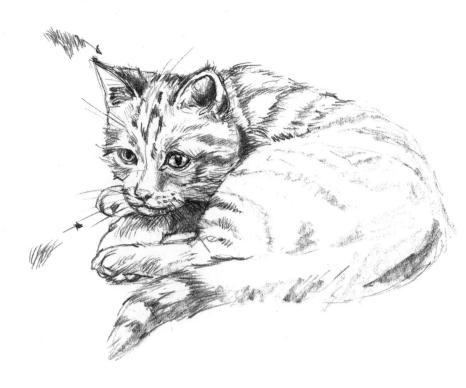

Step 5

I was happy with the way the head and shoulders were progressing, so I started suggesting darker tones under the chin and on the paws and tail by using shading and hatching, referring back to my little thumbnail drawing that I did at the beginning to make sure I was getting the shapes right.

Step 6

I created the illusion of the fur going around the cat's leg and body by following their contours, giving a three-dimensional look. Finally, I finished off the tail with some more hatching and I was done.

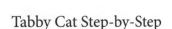

Rottweiler Step-by-Step

Dogs are very expressive creatures, so when you draw them it's important to catch their character and pose.

Materials and Equipment

- 8B Derwent watersoluble sketching pencil (dark wash), or any similar watercolour pencil
- 220gsm (100lb) cartridge paper
- Watercolour brush, No. 8 round
- Putty rubber
- Pencil sharpener

Step 1

Using my Derwent watersoluble pencil, I sketched the dog in a loose manner. I checked that it looked in proportion, consulting my reference as often as needed and making any changes that I thought necessary to get the overall figure right.

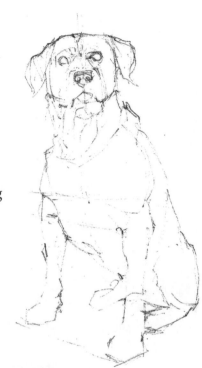

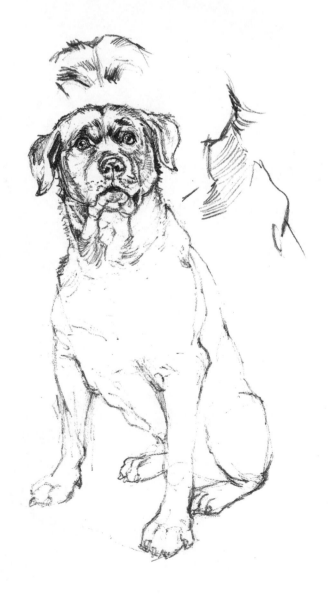

Step 2

I like to start with the eyes – other artists leave them until the end, while some even believe you should start from the ground up. I feel I have to get the eyes right first before I move on.

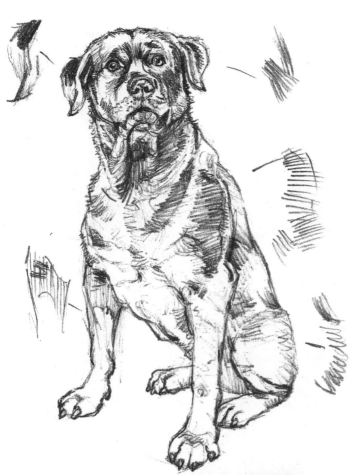

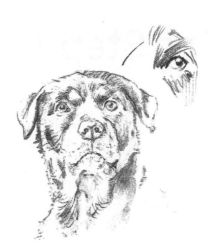

Step 3

I added more detail to the body, following the lines of the dog's coat with a mixture of contour lines and hatching and shading. When I stepped back to look at the drawing (always a good idea as we get so wrapped up in drawing that we sometimes miss glaringly obvious mistakes), I realized I'd made the dog's ears too large. I decided to redraw the ears and alter the angle of the head slightly, so I grabbed my putty rubber and did some erasing. This is always a worrying time, in case the next attempt isn't as good – but when you know something isn't right, be brave. You drew it once and you can do it again.

Step 4

Once I had redrawn the head and ears I started to erase some of the guidelines. Now I was ready to add a wash to the drawing. I let a brush loaded with water glide over the drawing to give it an all-over tone. Once this was dry, I added slightly less water to the brush and worked into the areas where I had laid a heavier, darker tone. Where the wash was getting too dark or wet, I lifted off the surplus with a tissue; for areas that were too light, I used the watercolour pencil to draw back in and added a small wash.

Fat Cat Step-by-Step

This is a fun cat to draw. Because the fur is so dense, nearly all the form is in the features themselves.

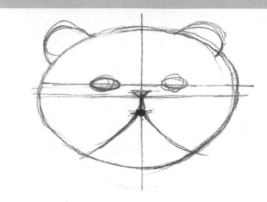

Step 1

I started with a rough circle shape for the head, then divided this in half for the position of the nose and drew a line down the middle to give me a guide for the nose and mouth. Just above the horizontal halfway line I drew another line to mark the level of the eyes, and just below it I drew in a point for the mouth. From the mouth dot I drew what looks like the top of a tent.

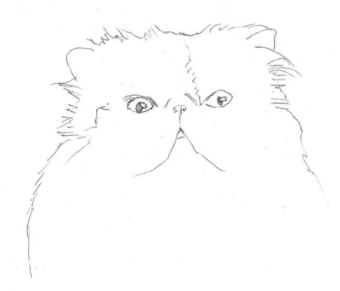

Step 2

The basic cat head was done now, so I started to draw in the eyes and outline the head, erasing the early guidelines.

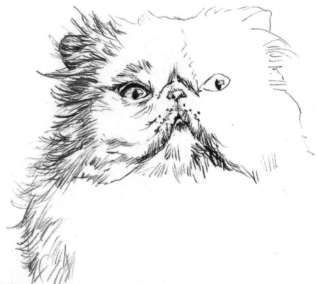

Step 3

I began drawing from left to right, adding details to the eyes, cheeks and ears. Working this way means that you avoid smudging your drawing as you go (if you are right-handed). I consulted my source material to see the direction and rhythm of the fur, but I didn't want my drawing to look like a photograph so I allowed my pencil strokes to be loose and had fun.

Step 4

I began to work on the other side, adding more shadow lines to the chin and cheeks, though I was tempted to leave it unfinished like this as it looks as if there is a strong light coming from the right.

Step 5

I finished off the right-hand side, but kept the weight of my pencil strokes lighter as the light was coming more from this side. Once I felt satisfied with the drawing I added some looser cat hairs so that it didn't look too tight. The final rather messy drawing gives the cat more character.

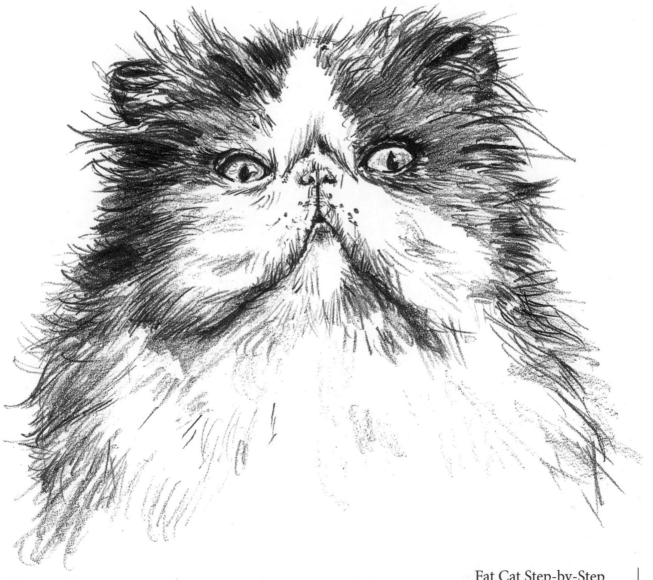

Dachshund Step-by-Step

These little dogs are just great to look at –
short legs, a muscular long body, a long snout
and large paws, and yet somehow it all works
together. I've included a little silhouette
breakdown of the dog below to show you the
bone structure to help on this exercise.

Materials and Equipment

- 3B and 5B pencils
- 220gsm (100lb) cartridge paper
- Putty rubber
- Pencil sharpener

Step 1

Again, I started with a
simple outline of the dog,
using the 3B pencil and
making sure I got the
proportions of the long
body just right. I jotted in
the eye and nose and added
a suggestion of the shoulder
and ribcage.

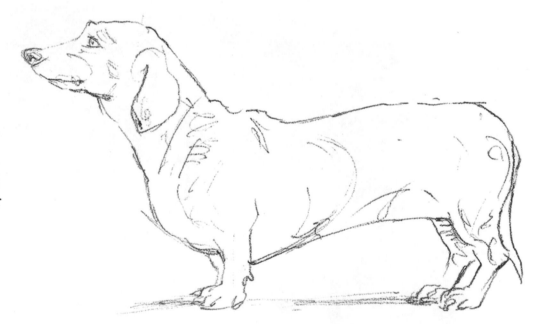

Tip When you're not sure what to do next, sometimes it's best to
stop drawing. Walk away from your work, make a cup of tea
and relax. When you go back refreshed, nine times out of ten
you'll be able to see how to proceed.

Step 2

For the next stage I switched to the 5B pencil, which allowed me to add nice dark lines and tones to build up the head and chest area.

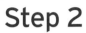

Step 3

I then continued adding more hatching and tone through the mid body and hind legs, making sure that I left a lot of white space to create the idea of light hitting the dog. I smudged some of the tone to create the underbelly shadow.

Step 4

I began laying down lots of dark tone, shading it as I went, then picked out the lighter areas with a putty rubber around the eye and ear where I had overdone the tone. I smudged up from the belly to create a nice graduated effect, going from dark to light. I also laid down more lines over some parts of the tone to create the shiny look these dogs have. Then I decided that I had finished – I didn't want to overwork this drawing and ruin it.

Parrot Step-by-Step

I found a lovely cheeky little parrot picture and thought it would be great fun to draw. These are particularly characterful birds, so the eye would be very important here.

Materials and Equipment

- 2B pencil
- 130gsm (50lb) cartridge paper
- Putty rubber
- Brush pen
- Watercolour brush, No. 8 round

Step 1

Using ovals and circles, I quickly drew the shape of a parrot's head with a pencil. Once I had established that I worked it up into an immediately recognizable representation of the bird and erased the guidelines. I darkened the eye, leaving highlights to give it life. Next I suggested the feathers on his head and breast and added some texture and scratches to his beak. That was as much as I needed to draw with the pencil – the brush pen would do the rest.

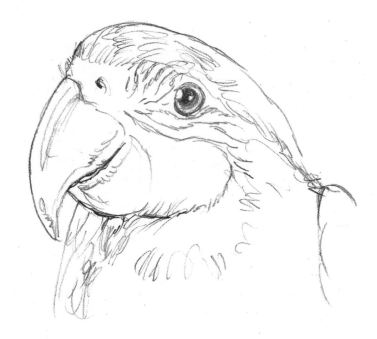

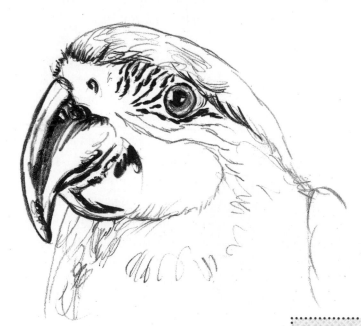

Step 2

Next I went over my pencil lines with the brush pen, slowly building up the parrot into an ink drawing and adding more detail to the beak and chin.

Tip Always leave plenty of white paper showing – it adds sparkle and a suggestion of light to your finished piece.

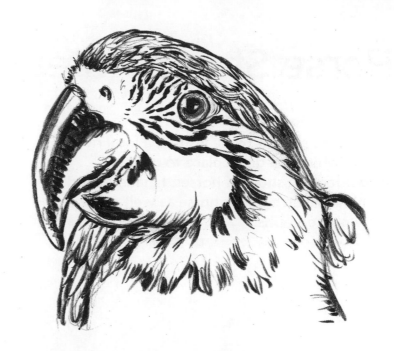

Step 3

I continued to flesh out the bird, introducing darker tones where I would want more of a wash later. I concentrated on the beak area as I wanted a nice graduation here.

Step 4

Putting down my brush pen, I picked up the brush and loaded it with water. I flooded the beak area under the highlight with water and let the wash do its business, keeping a tissue ready to soak up any overspills or excess water. Once I'd put a wash on, I dried my brush on the tissue and then immediately started to lift some of the wash I'd laid down – you can always darken an area again later, but it's more difficult to lighten it once it has dried. For the top of the beak I dipped my brush in water, mopped it so that there was just a hint of moisture on the brush, then followed the line of the beak, gently dragging the ink downwards. With a damp brush, I drew the ink up from under the neck feathers for the texture under the cheek and did the same above the beak. Using a light wash of water, I worked on the whole head. I used a damp brush around and in the eye, being careful not to muddy my highlights. I kept the patterned small feathers around the eye as dry as possible as I wanted these to remain strong blacks. I finished off with a damp brush beneath the feathers under the chin to suggest detail without there actually being much.

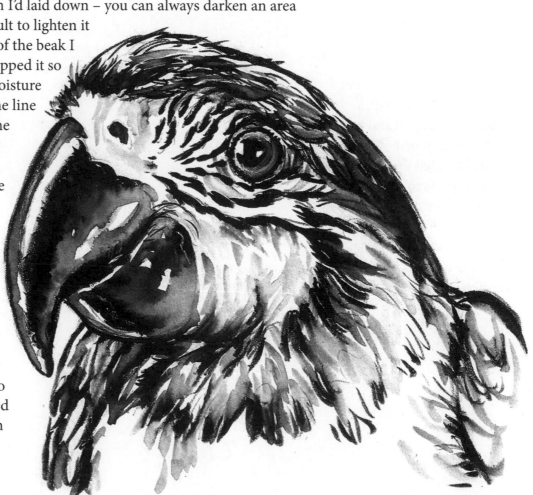

Horse Step-by-Step

I found this subject while visiting a local riding school, which is a great place to go if you need reference shots of horses. I made a quick thumbnail sketch of the horse as well as taking a few photographs.

Materials and Equipment

- 4B Derwent watersoluble sketching pencil (medium wash), or any similar watercolour pencil
- 220gsm (100lb) cartridge paper
- Putty rubber
- Watercolour brush, No.12 round
- Pencil sharpener

Step 1

I set to work with my Derwent watersoluble pencil, sketching a rough outline of the horse's head and neck and a rug fastened over its chest. I divided the face into three sections to get the proportions right and took some time to position the features in the right place, referring to my photographs as often as I needed to.

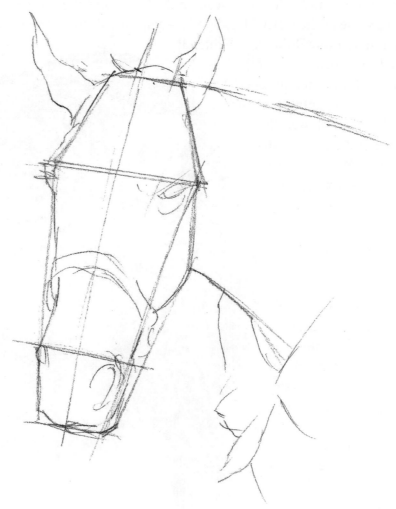

Step 2

I began to work more on the eyes and nose, adding more detail and erasing whenever I needed to change something such as the size of the nostrils. I defined the mouth a little, sketching in a bottom lip and then removing my guidelines. Then I defined the ears and added some floppy hair for the forelock.

Step 3

Next I put in additional details, varying the weight of my pencil line to create depth and light. I darkened areas such as the eyes, the hair and under the muzzle to create the illusion of depth by bringing the head into the foreground. I also added more detail to the bridle and some shadows above the nostril and the jawline.

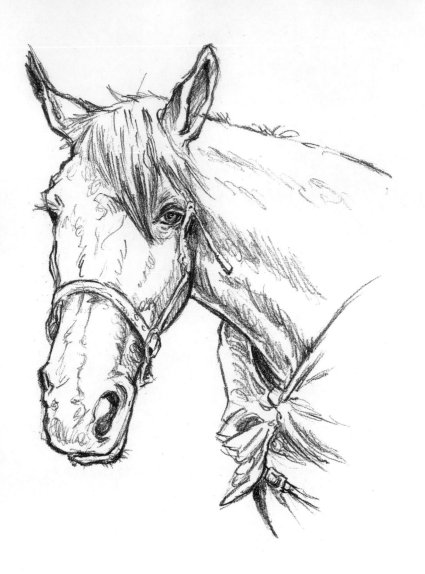

Step 4

I used the pencil to give more emphasis to the darkest parts of the drawing, adding shadow under the jaw, eyes and muzzle. Putting the finishing touches to the horse's forelock, I left the paper blank in places to create the illusion of highlights between my varied pencil strokes. I also added more detail to the nose, ears, bridle and rug. Finally I added some wispy hair to the neck to suggest the horse's mane and a few hairs on his chin. I stepped back to view my drawing from a distance and decided that it was ready for the pencil wash.

Step 5 (opposite page)

The beauty of the Derwent watersoluble sketching pencil is that it allows you to create dark washes very quickly in a painterly way. By washing the water into the areas of dark tone with a large watercolour brush I gave the drawing deeper blacks, adding more water to soften areas of mid-tones. I gently brushed the water around the eyes and under the chin and neck to make the head stand out but left a lot of white paper to give the impression of light falling on the horse. I added a wash over the forelock and finished the rug, keeping my style as loose as possible. Overworking a piece can ruin a drawing; unless you want a photographic finish you don't need to add every eyelash and hair. It's an impression of the subject you want to achieve, hopefully having fun along the way.

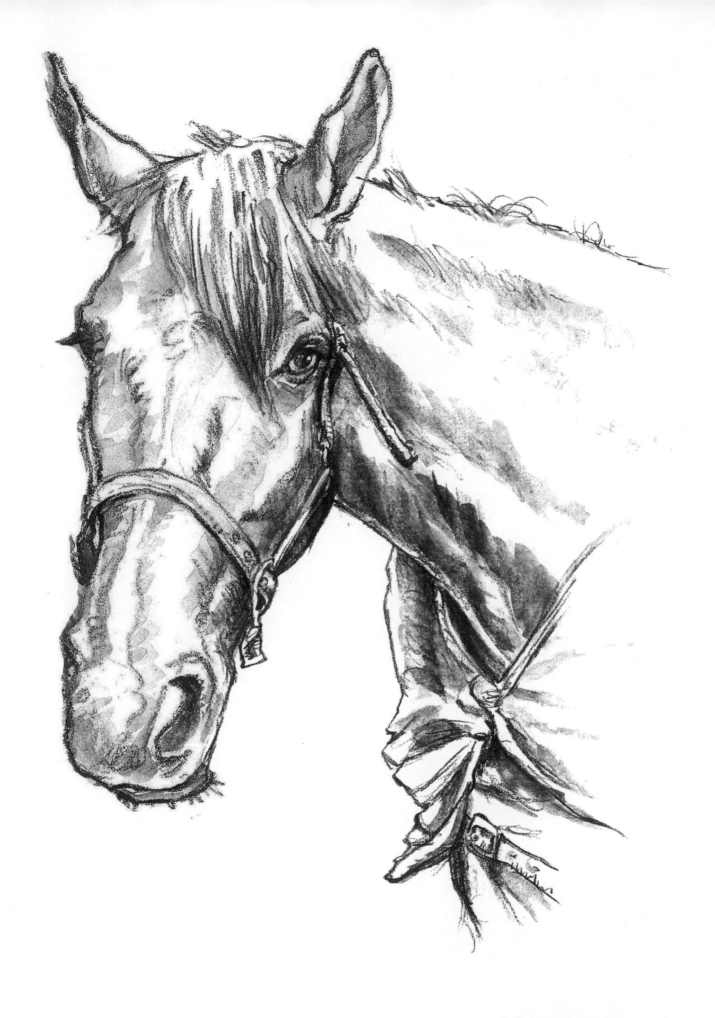

Chapter 3
Drawing from Life

In this chapter we'll be venturing out of the studio to see at first hand a variety of animals that always catch an artist's attention. You'll discover the value of sketchbooks, photography and the hidden treasures that are to be found in natural history museums, all of which will help you to explore animal forms and characteristics.

So, for your field trip you will need to pack pencils, a putty rubber, a pencil sharpener, a sketchbook and a pocket camera. You might also like to take a fold-down chair. If you think this seems like a lot to carry, then spare a thought for artists such as Van Gogh, who would go out in the dead of night to paint by moonlight, carrying his easel, oil paints, canvas, brushes, charcoal, solvent, food, chair and a large hat with candles strapped to it so he could see his canvas. Now, that is real dedication!

The Sketchbook

Sketchbooks come in all sizes from A6 to A1 and in styles from spiral-bound pads to handsome hardback books. I use an A4 sketchbook, treating it as a combination of notebook and diary for drawings. You can fill yours with doodles, ideas or finished drawings as you like – just try to make drawing in your sketchbook a habit, since doing this every day will help you to develop your style and dexterity with a pencil or pen and improve your observation skills too.

Charting your progress

It's a good idea to get into the habit of putting the date in the corner of the page when you have finished a sketch. That way, when you flip through the drawings, you'll be able to see the improvements in your work from the beginning until the present time. You'll be amazed by how quickly your drawing skills will improve with daily practice.

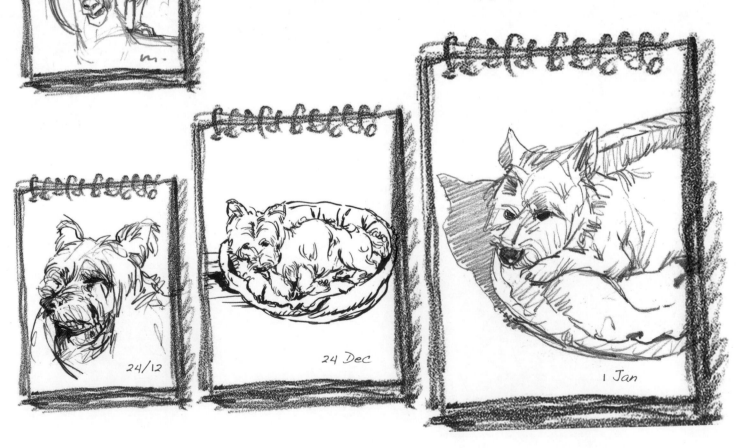

Fast sketches

When drawing for the first time, most people make the mistake of trying to draw everything in front of them. This can be overwhelming and leads to frustration and lots of pencils being thrown around the room. The beauty of fast sketching is that all you need to do is capture the important things – in the case of animals, the pose, the shapes and the expression. You can always go back to your sketch later if you want to develop it.

If you're drawing from life, you'll soon find out the animals hardly ever stay still for long, so fast sketching is your only option. There's an exciting challenge in that and it's great practice in drawing loosely and decisively, but if you do want to make a more considered sketch the best time to do it is while they're resting.

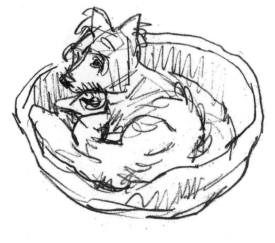

Down on the Farm

For many of us, the first place to find some animals of different shapes and sizes is on a farm – I've drawn a typical variety here. If you live in the country you probably have a choice available, while in urban areas there may be city farms that can be located by checking in your local library or directory or searching online.

Remember that your task here is not to do a finished detailed drawing, as you are learning about sketching and being able to do quick, loose drawings; if you do find a stationary subject you can take your time, but it's not the main event. Above all, have some fun and enjoy drawing out of doors.

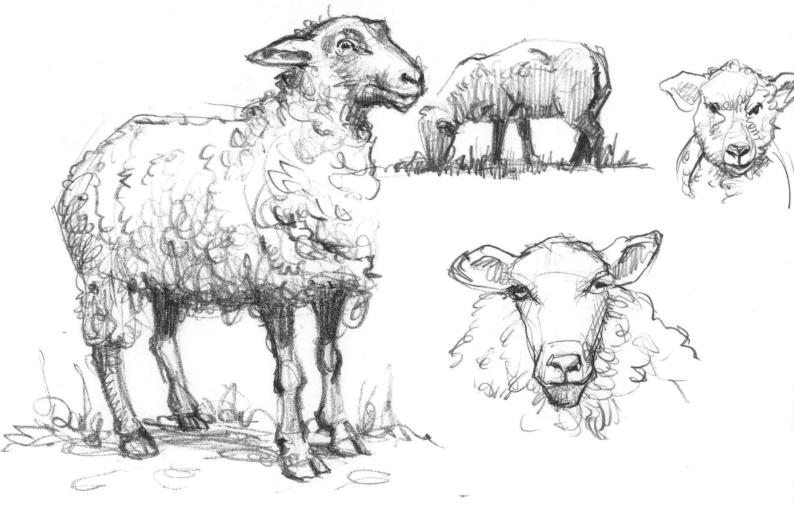

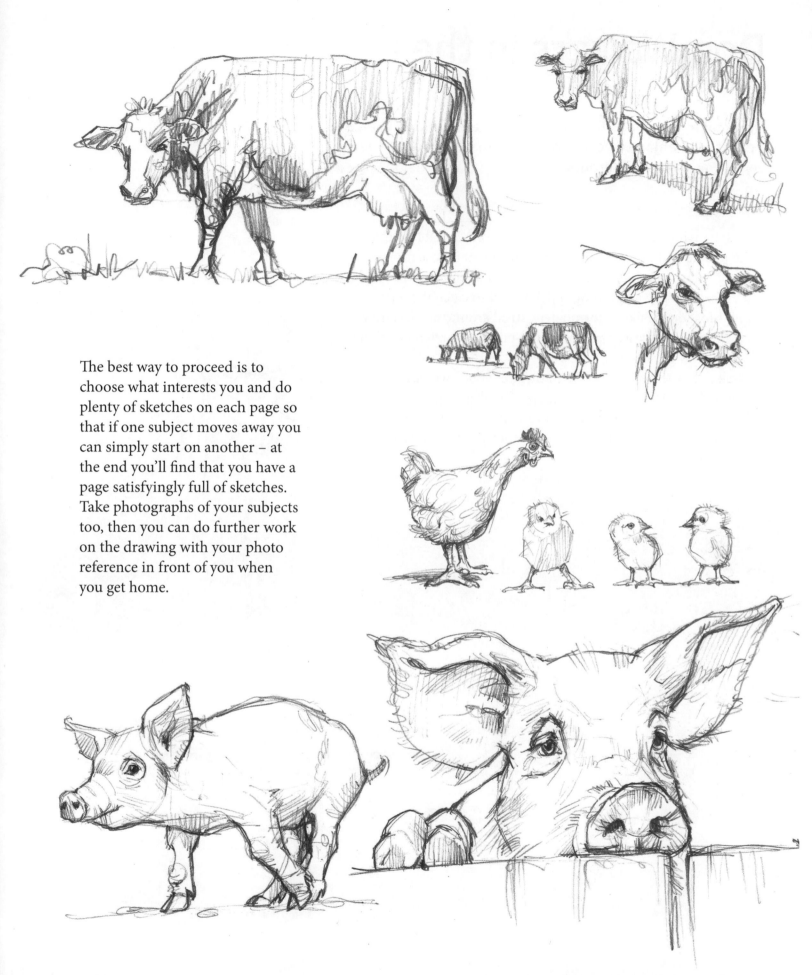

The best way to proceed is to choose what interests you and do plenty of sketches on each page so that if one subject moves away you can simply start on another – at the end you'll find that you have a page satisfyingly full of sketches. Take photographs of your subjects too, then you can do further work on the drawing with your photo reference in front of you when you get home.

Dog Walkers in the Park

I love taking my dogs to the park for their morning exercise. Best of all, I enjoy watching how all the other dog owners behave as they walk around.

A park bench is the perfect place to draw from. You'll find that some people will be more than happy to stop and pose for you once you start chatting to them. Others will be more elusive and you'll need to have a lightning-quick pencil to catch them on paper. Most dog walkers, fortunately, stroll around at a leisurely pace, though I still carry my camera to take some reference shots of those great but fleeting poses.

Back at home, you can work on these at your own pace. Don't be disappointed if they're not perfect drawings; these are exercises to help you improve your drawing skills and become accustomed to drawing outside, away from your comfort zone.

They say dogs look like their owners!

Darling, I'm too busy to notice what business my dog gets up to: and I'm certainly not picking it up!

Who's taking who for a walk?

You may not be able to capture all the regular characters in one visit, but if you make your trips to the park a frequent occurrence you'll soon fill your book with lots of interesting and amusing drawings of the dog walkers and their pets.

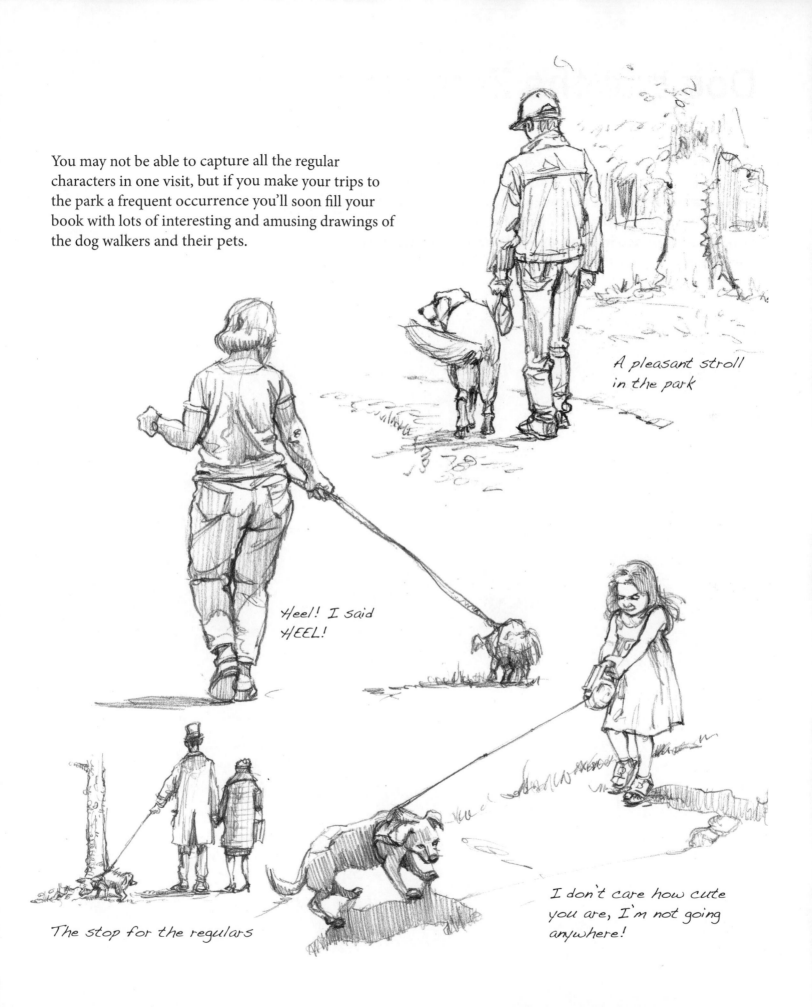

A pleasant stroll in the park

Heel! I said HEEL!

The stop for the regulars

I don't care how cute you are, I'm not going anywhere!

Going to the Zoo

There's nothing like coming face-to-face with wild animals for the first time – watching them on television is no substitute. A visit to the zoo to see monkeys, lions, elephants, rhinos and so on in the flesh will give you a thrilling experience in itself as well as a chance to draw these animals.

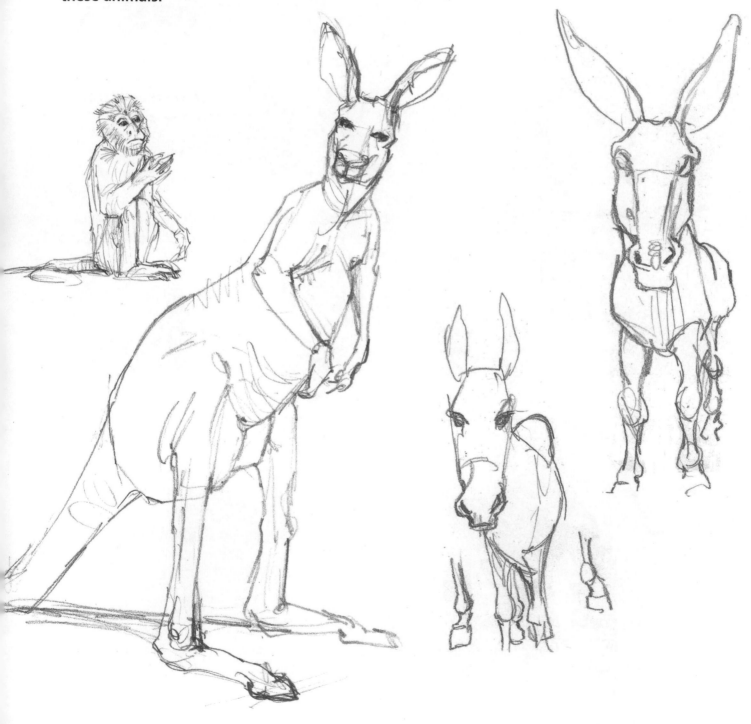

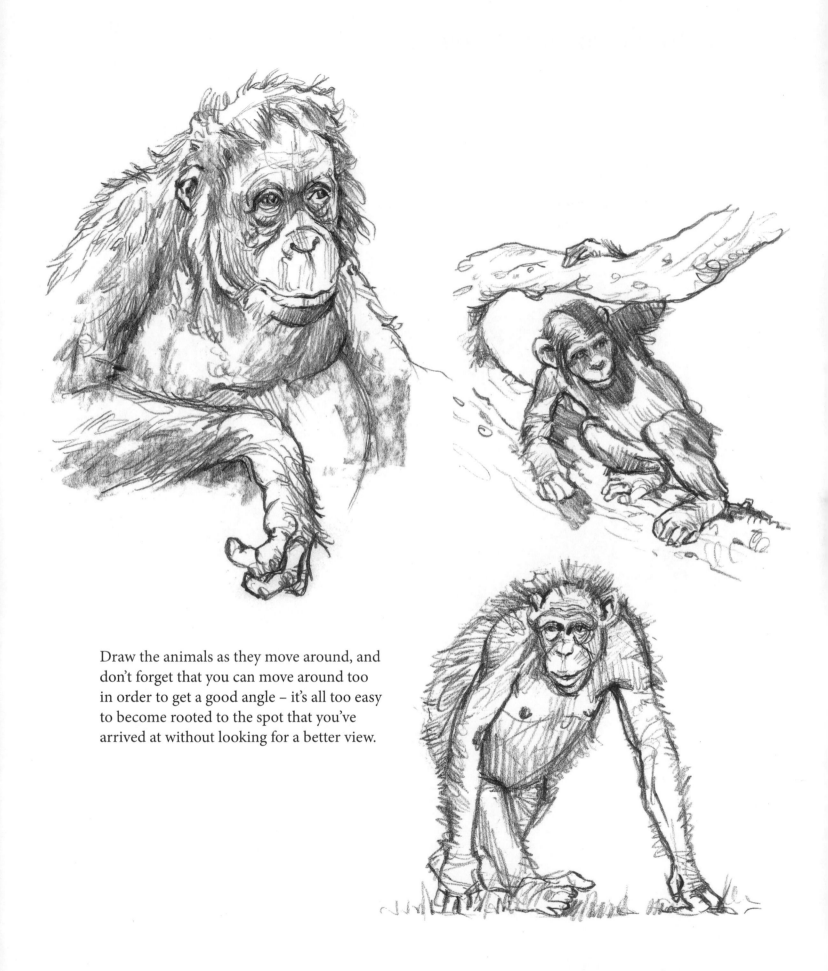

Draw the animals as they move around, and don't forget that you can move around too in order to get a good angle – it's all too easy to become rooted to the spot that you've arrived at without looking for a better view.

Going to the zoo (continued)

I've included a selection of my drawings of zoo occupants. Remember that yours needn't be as finished as mine – try to keep them loose and fast unless you come across a subject who is fast asleep, when you can take your time and do a proper study.

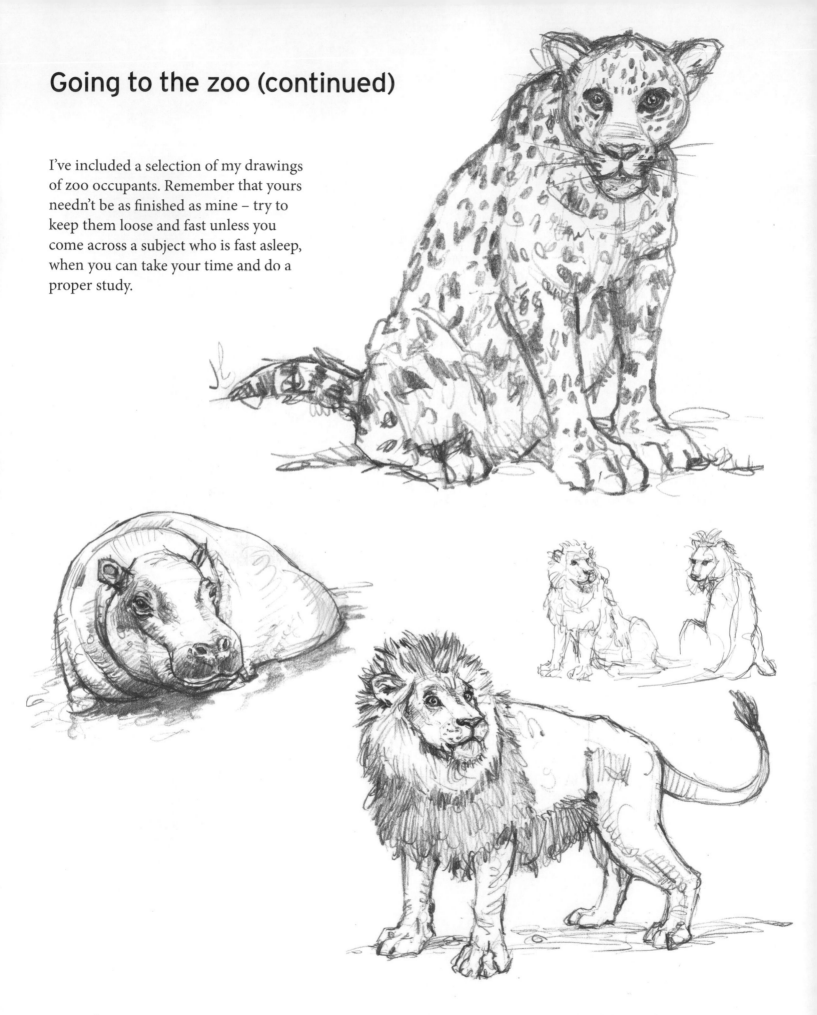

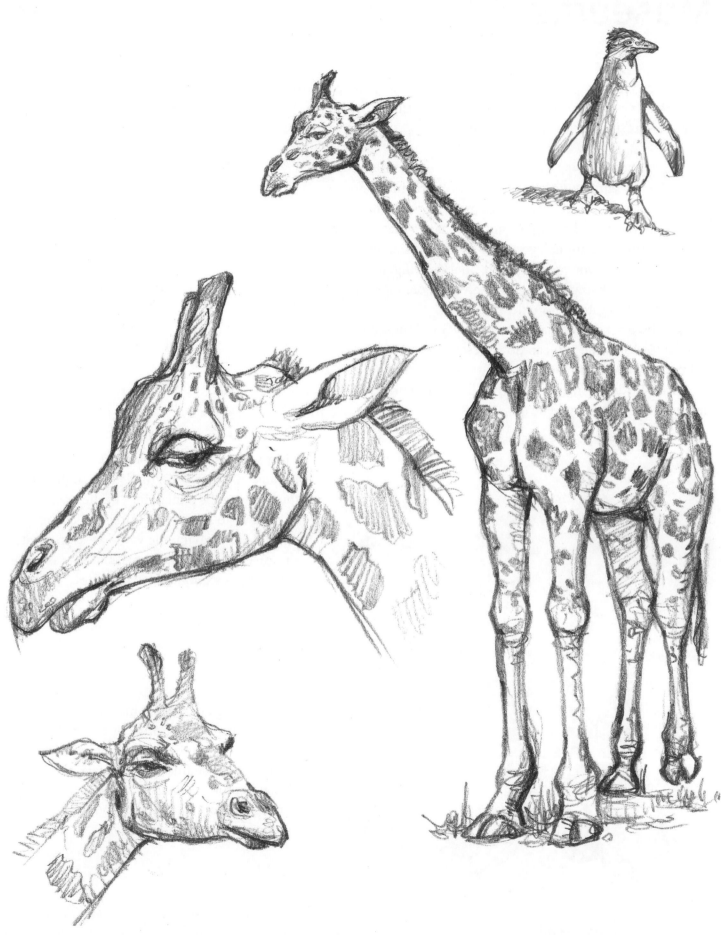

Museums

After zoos, farms, parks and trying to wrestle your pet into a particular pose you want to draw, museums are the next best alternative for finding a model.

They offer the same static subject as a photographic reference does, but have the added advantages of giving you a three-dimensional view and also the ability to change that view by moving around the animal, getting a feel for its size and bulk, which helps when you're doing your final drawing. It also allows you to pick unusual angles to create more interesting drawings and to gather more detail.

These quick sketches that I drew in my local museum are examples of what you can do yourself. My museum is an impressive one, but it doesn't matter if yours has only a few native birds and mammals – you'll still find plenty of fascination in drawing them.

I just had to draw this goofy African deer because its expression made me laugh out loud. I used the pencil lines in the areas of shadow to suggest the direction of the animal's fur, leaving the white areas to create the effect of light. The pencil I used was a 4B, which gives a good variety of tones.

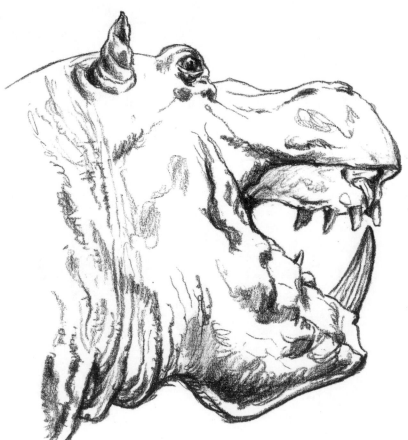

I loved being able to get this odd view of a hippo. It would be impossible in real life, but this is one of the beauties of being able to draw in museums. I used a dark charcoal pencil to quickly block in the tone and kept it all fairly loose and light. It took me about 10–15 minutes to complete.

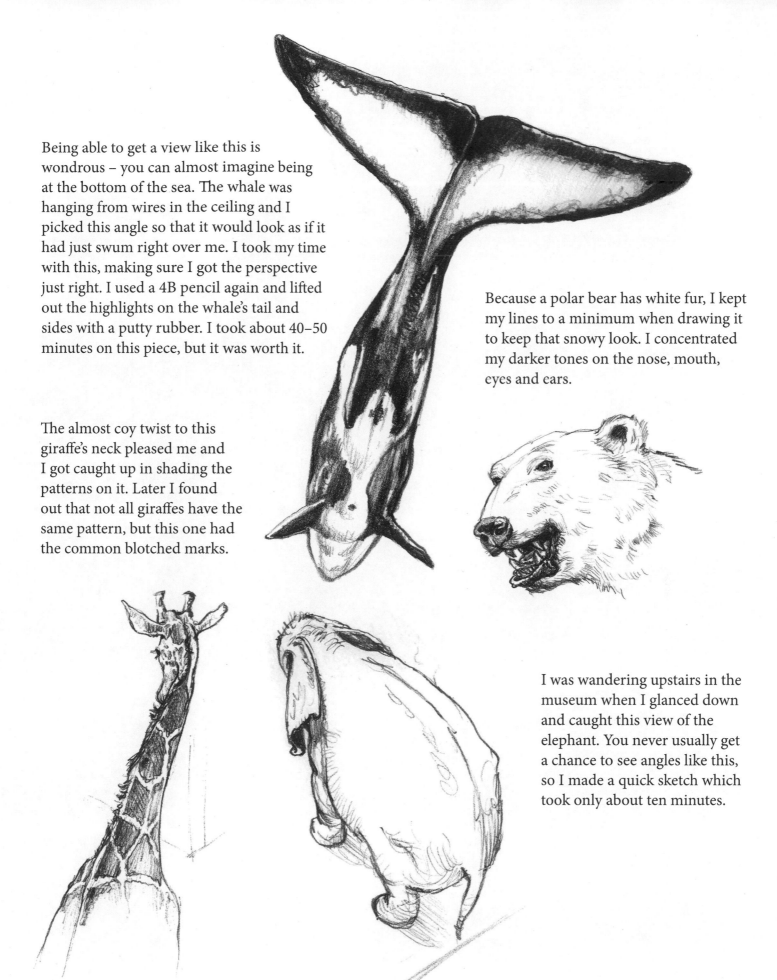

Being able to get a view like this is wondrous – you can almost imagine being at the bottom of the sea. The whale was hanging from wires in the ceiling and I picked this angle so that it would look as if it had just swum right over me. I took my time with this, making sure I got the perspective just right. I used a 4B pencil again and lifted out the highlights on the whale's tail and sides with a putty rubber. I took about 40–50 minutes on this piece, but it was worth it.

Because a polar bear has white fur, I kept my lines to a minimum when drawing it to keep that snowy look. I concentrated my darker tones on the nose, mouth, eyes and ears.

The almost coy twist to this giraffe's neck pleased me and I got caught up in shading the patterns on it. Later I found out that not all giraffes have the same pattern, but this one had the common blotched marks.

I was wandering upstairs in the museum when I glanced down and caught this view of the elephant. You never usually get a chance to see angles like this, so I made a quick sketch which took only about ten minutes.

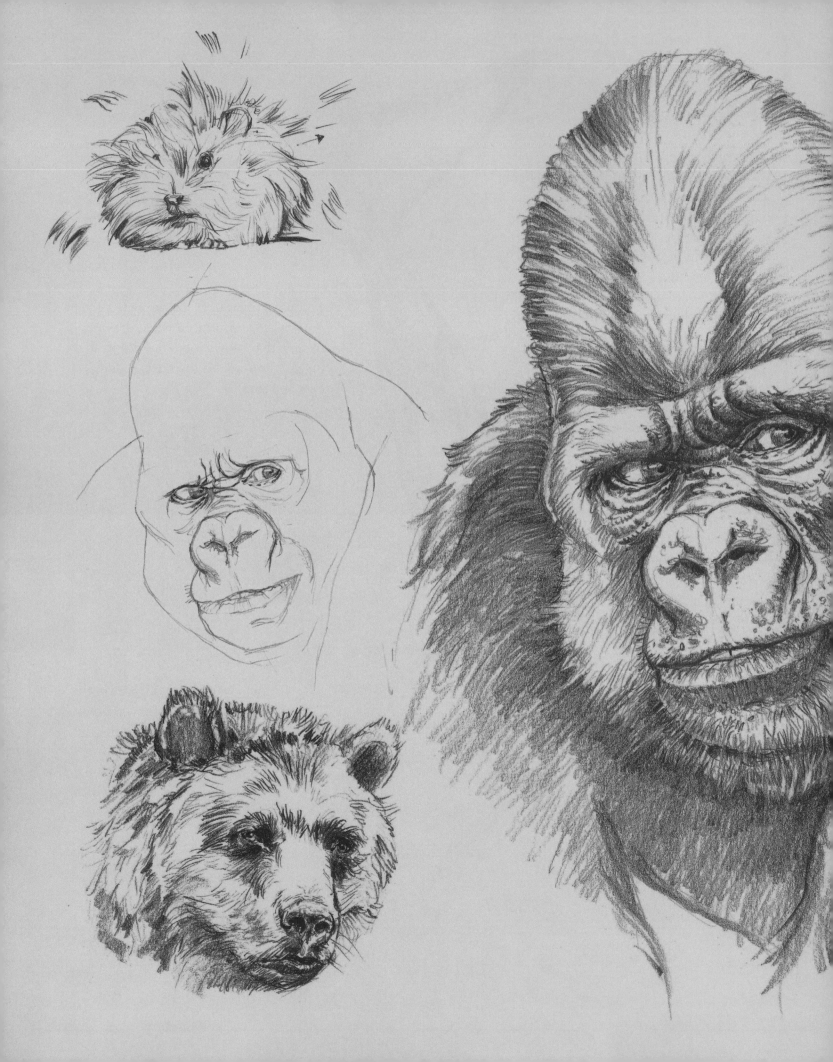

Chapter 4
Textures

Drawing the texture of an animal's surface, whether it's hair, fur, scales or feathers, is a matter of taking your time to observe it closely. You'll see that it follows the contours of the muscles and bones that lie below, often changing in pattern as it does so, indicating details of the form of the animal. Notice how it looks where the light hits it and where it's in shadow, and think about how you can translate its texture on to your paper.

Over the next few pages I'll show you some tips on how to draw the various types of animal coats. Have a go at copying them and when you come to do the next step-by-step demonstrations, you'll know how to achieve better results.

Angora Guinea Pig

This is a good exercise to start with in our study of texture, as the main feature of this animal is its very long fur, which means that little of its body can be discerned.

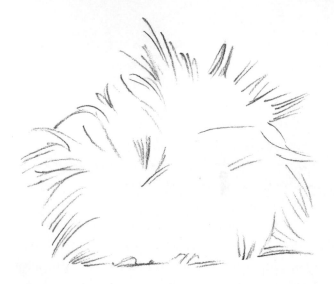

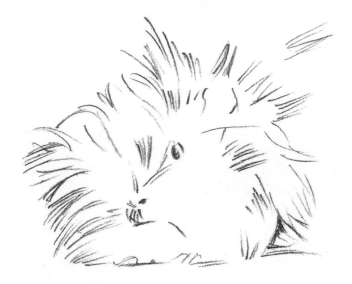

Step 1

I started by drawing a fluffy ball shape, keeping the lines light and loose.

Step 2

Next I added some more lines radiating out from the centre, then added a circle and something that looks vaguely nose-like.

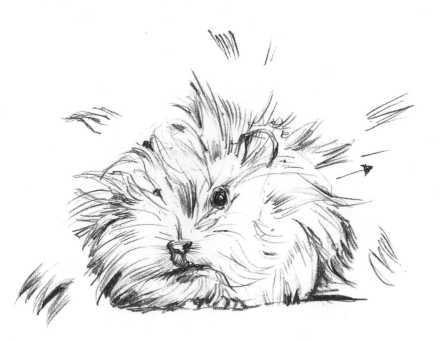

Step 3

I darkened the eye and added one full ear and one that's partially hidden. Then I filled in the rest of the hair, keeping to the original shape. Finally I finished off the nose and added the mouth, moustache and beard, and part of the hidden eye before rendering the toes. I've added the types of lines and the direction they were drawn in so you can see how the drawing was built up.

Varying Textures

You may feel that rendering textures as different as fish scales and thick fur is going to be a huge challenge, but in fact all you need to do is use different marks with your pencil and carefully note how the light affects the surface.

As you can see from this preliminary sketch of a bear's head, I've created the shape of the head and suggested the eyes, ears, nose and mouth with just a few lines.

On the final, more finished drawing I've only added the details of the eyes, nose and mouth shapes, and the fur is just an elaborated version of the first sketch. I used more contour lines and some tone around the eyes and nose. This is still not a highly detailed drawing, but less is often more. I left a lot of white areas to create the suggestion of light, which in turn works with the dark tones to create a nice three-dimensional bear.

With any subject, you have to judge for yourself what's relevant to your drawing and refrain from including every detail for its own sake. In fact, once you become more confident in your drawing skills, try a looser, more impressionistic type of drawing as you develop your own style.

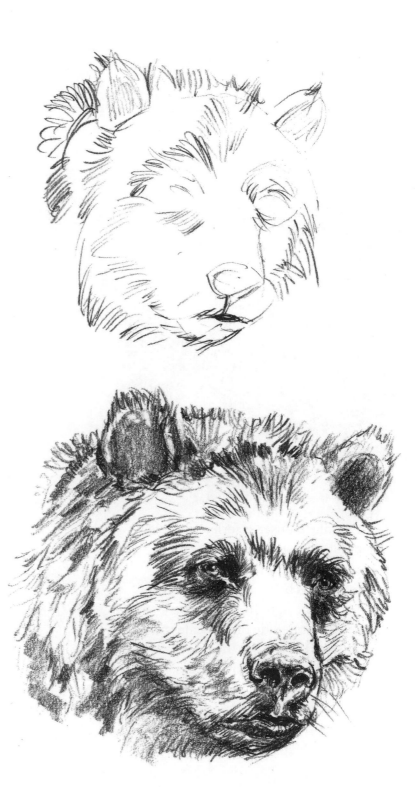

Varying textures (continued)

Here you can see an initial sketch of a Yorkshire terrier's tail, made by simply following the lines of the tail to give me the shape I needed.

Next I drew the whole dog using directional lines – there are no outlines here, just the shape the dog's coat makes as it twists and turns.

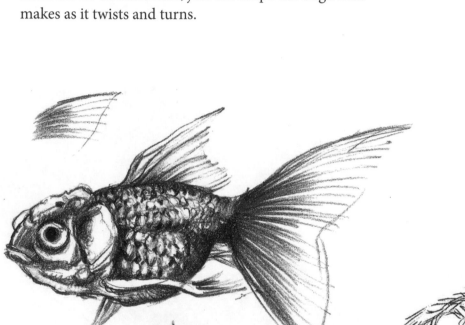

For the goldfish, I used a series of overlapping oval shapes to create the chain-mail texture of the scales that cover most of its body. It was important to emphasize the light here by using a dark pencil on one side of the scales to suggest it curving around the body. On the fins and tail the darker lines create the appearance of shadow, while the finer lines give the impression of light passing through the tail.

Find a reference picture and create something like the first image I've done here with the chimp, using only the contour lines of the hair on his body.

In the second drawing the contour lines are combined with an outline.

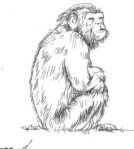

In the case of the iguana I've suggested the texture by adding detail in certain areas and leaving other areas just hinted at to avoid my drawing becoming too laboured and bogged down in detail. I created the chain-mail effect on the 'shoulder' by using a series of cross-hatched lines, with darker lines to represent shadow and finer, lighter lines to suggest light.

Around the mouth I built up what look like large tooth shapes, which then change into smaller diamond or hexagon shapes around the rest of the head. You can see I let these fade out until there's just a suggestion of them. The only area I gave detail to is the eye, which holds the piece together.

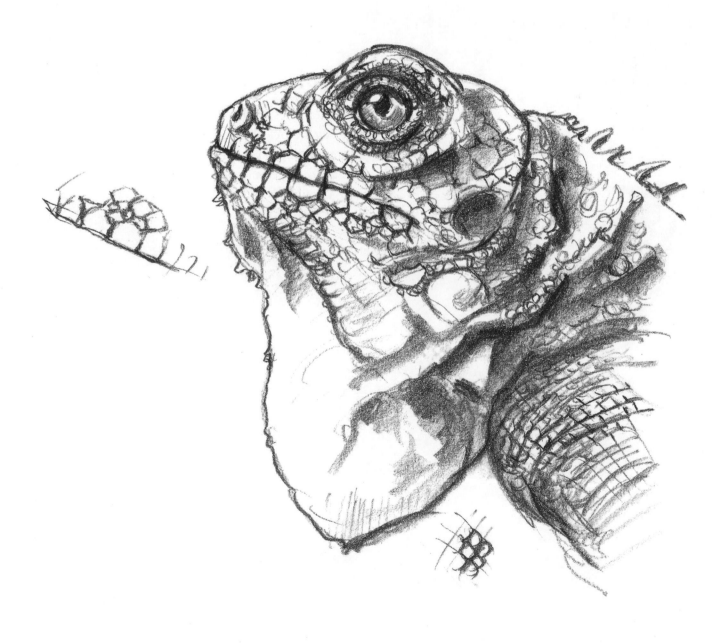

Canary Step-by-Step

Once you've mastered drawing the feathers of one bird, you're all set to cope with drawing any type. While the size and colour of feathers varies, the texture remains similar in all breeds.

Materials and Equipment

- 8B Derwent watersoluble sketching pencil (dark wash)
- 220gsm (100lb) cartridge paper
- Watercolour brush, No. 8 round
- Putty rubber
- Pencil sharpener

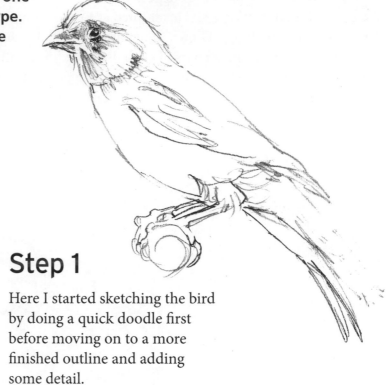

Step 1

Here I started sketching the bird by doing a quick doodle first before moving on to a more finished outline and adding some detail.

Step 2

Next I started working on the head and trying to follow the lines of the feathers, but after a while I felt I was adding too much detail.

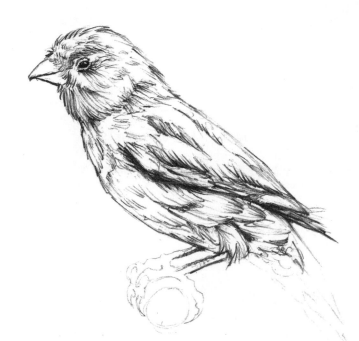

Step 3

The original drawing was too busy with detail and it just wasn't how I wanted the bird to look, so I rubbed out all the underside including the tail and started to redraw with more care. I used simpler, lighter lines to suggest the feathers.

Step 4

I was finally beginning to achieve what I wanted. I redrew the tail, following the line of the feathers without actually drawing them in detail. Now the drawing was really coming together. I added tone to the beak and the underside of the wing and quickly drew in the legs and talons. This little bird was more difficult than I thought it was going to be! Because I was looking too closely at all the intricate details of the feathers in the beginning, I fell into the trap of putting in more detail than I could actually see.

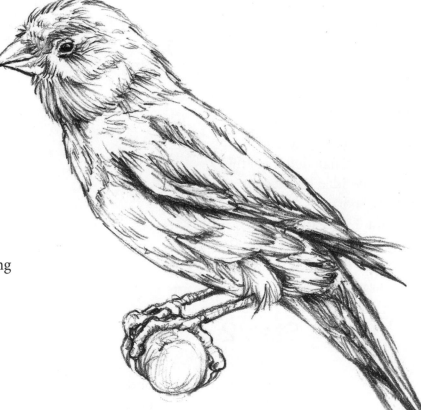

Tip When you're drawing something that looks complicated, try squinting at it with half-closed eyes to see just what is important. Draw that first, then worry about the details later.

Gorilla Step-by-Step

A gorilla is a much more ambitious project than a domestic pet. I could have gone to the zoo, but as I wanted to make a detailed drawing in close-up, working from a photograph was the only practical way to do it. I sourced one of a mountain gorilla and set to work.

Materials and Equipment

- 2B, 4B and 8B pencils
- 220gsm (100lb) cartridge paper
- Putty rubber
- Pencil sharpener

Step 1

Using a 2B pencil, I began by sketching a rough outline of the head and divided the face to get the proportions right. Then I took some time to position the features in the right place, referring to the photo reference as often as I needed.

Step 2

Continuing with my 2B pencil, I began to work more on the eyes and nose, adding more detail for depth and using my putty rubber whenever I needed to change something such as the size of the nose. I started to define the mouth and chin and sketched in the bottom lip and a suggestion of teeth.

Step 3

Switching to my 4B pencil, I drew lines to create the texture of the hair on the gorilla's face. Here, I varied the weight of the lines to create depth and light, making sure the lines followed his contours. I darkened the areas behind his cheek and eye socket to create the illusion of depth, bringing his cheek and face into the foreground. I also added detail to the nose and shadows to the lower lip, making sure my pencil lines followed the angle of the animal's chin.

Although I was happy with the way the drawing was progressing in some respects, there was something bothering me about it. I propped the drawing upright and stepped back to see it from a distance and with a fresh perspective, whereupon I immediately spotted the problem. Checking the reference photo, I could see that the top of the head should be much larger.

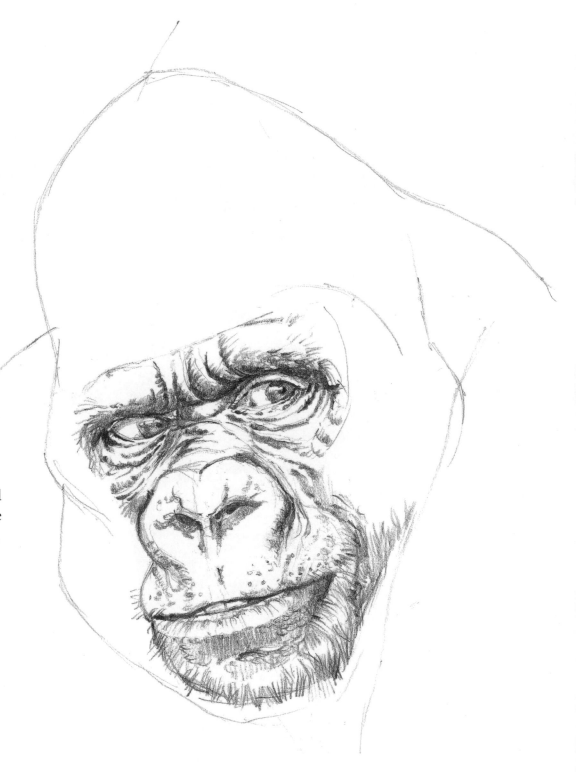

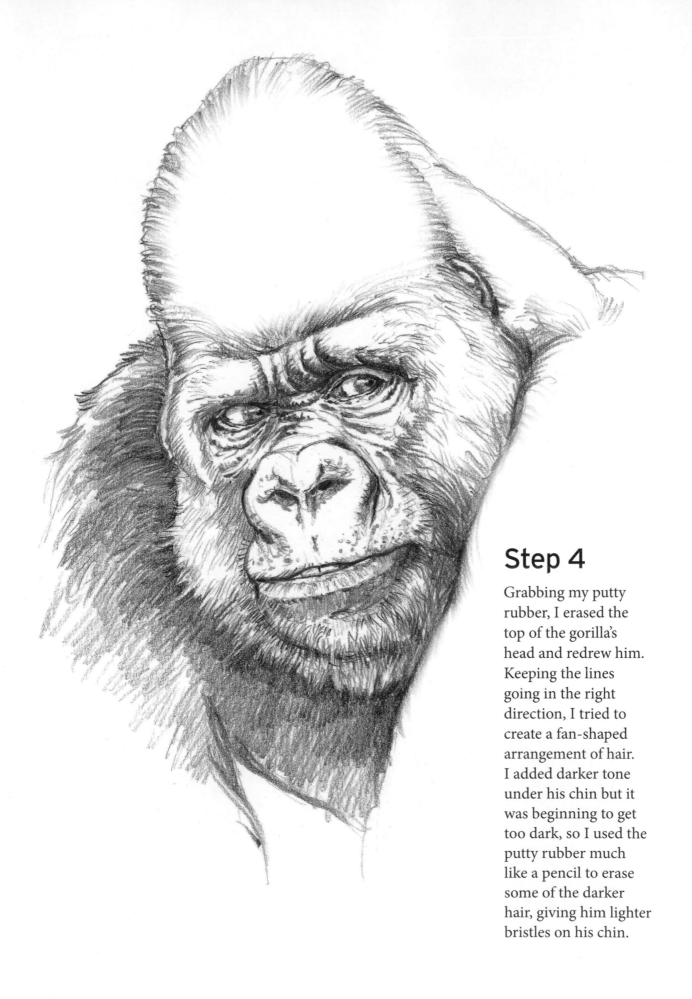

Step 4

Grabbing my putty rubber, I erased the top of the gorilla's head and redrew him. Keeping the lines going in the right direction, I tried to create a fan-shaped arrangement of hair. I added darker tone under his chin but it was beginning to get too dark, so I used the putty rubber much like a pencil to erase some of the darker hair, giving him lighter bristles on his chin.

Step 5

With my 8B pencil, I emphasized the darkest parts of the drawing, adding more shadow under the brow, eyes and nose. I put the finishing touches to the gorilla's hair, leaving the white of the paper showing in places to create the illusion of highlights between my varied pencil strokes. I added more details to the nose and lips, drawing in a few blemishes, and shaded the right corner of his mouth to give him more expression. Still using my 8B, I made wider pencil strokes to give a suggestion of his neck and shoulders. I stepped back again to view my drawing from a distance and decided that it was finished.

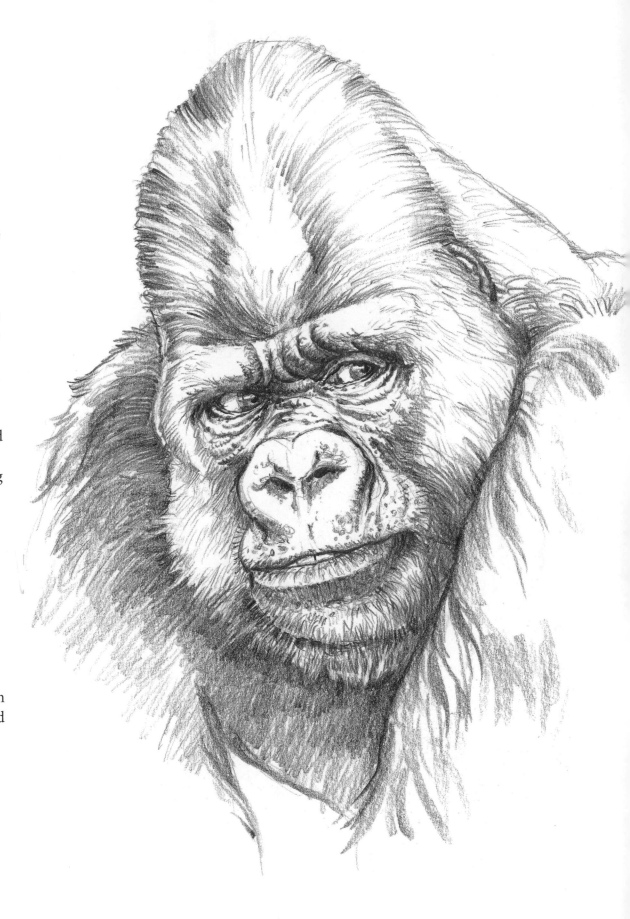

Chapter 5
Light and Shade

Throughout the centuries, artists have manipulated light and shade in their paintings to evoke the desired mood, emotion and atmosphere. Probably the most famous for their use of dramatic light and dark were Caravaggio and Rembrandt, both of whom often showed their subjects brightly lit but surrounded by deep shadow — an effect known as chiaroscuro.

When you're drawing pets or other animals, you'll probably be using normal everyday lighting to keep your work light and bright. Nevertheless, it's good to have other approaches up your sleeve for times when you want your pictures to tell a different story.

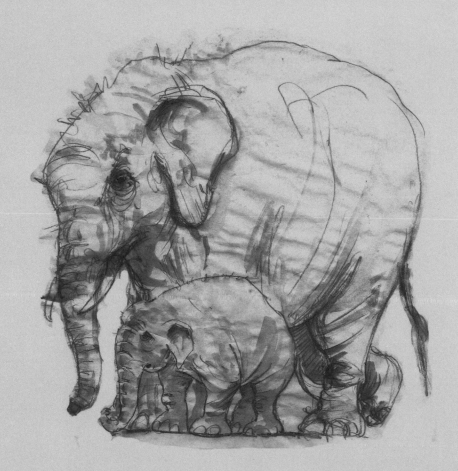

Dramatic Lighting

Lighting changes our perception of how we see things. Consider how a landscape well known to you affects your mood when it's bathed in bright sunshine casting dark shadows, shrouded in mist in flat tones of grey or overcast by a dramatic stormy sky with light piercing the clouds here and there. In just the same way, lighting dictates the atmosphere of a piece of art.

Here are some examples of how lighting from different directions can change the appearance of your subject.

Lit from above

Lit from the side

Lit from below

In the next series of images, you can see how your lighting choices can dramatically change your composition and the effect it has on the viewer.

Here we have a beautiful Arctic wolf: he looks quite placid in this drawing.

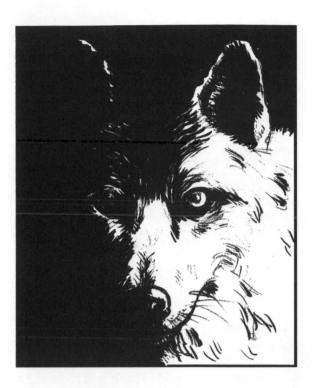

As you half doze in front of your television, from the corner of your eye you see what you think at first is man's best friend. But is this actually a dangerous wild animal?

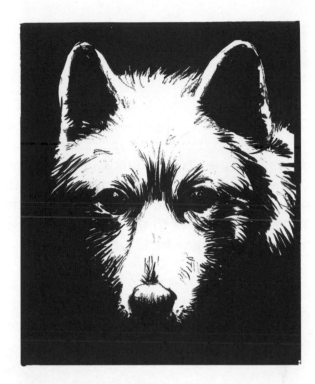

The wolf is now something from a half-remembered nightmare – do you run, or risk standing your ground?

Hiding in the shadows, the wolf pokes his nose into the light, testing the air to make sure the moment is right for a strike.

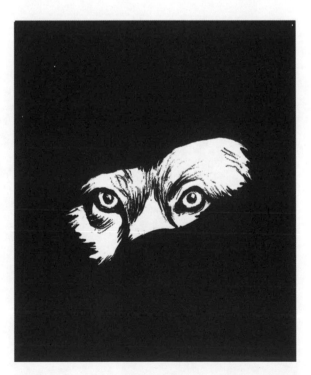

With everything lost in the blackness it's difficult to tell what is lurking in the shadows. Whether it's a man or beast, it looks threatening.

Tone

'Tone' refers to the light and dark areas found in any painting or drawing. Variations of tone graduate from white light through degrees of grey to the darkest black.

The use of tone helps the artist to create the illusion of three dimensions in a painting or drawing. In general, the light tones appear to be closer to the viewer whereas the darker tones help to make the image look further away.

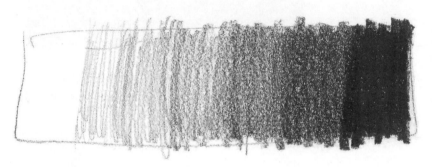

Here is an example of a tonal scale, which you can use as a guide when you're doing a tonal sketch. It starts at white and has deepening shades of grey right through to black.

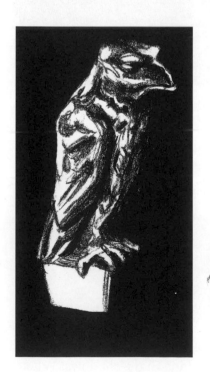

Here I've used a version of the bird statue from the film *The Maltese Falcon*. I always think of film noir when I am making dramatically tonal drawings. Tonally this is a simple piece, but with the introduction of a black background it has an air of mystery and intrigue.

In the second drawing the falcon is set against a white background and here you can see the complete bird and the subtle graduation of tones as they disappear into the shadows. Notice how the surface of the table reflects light back on the base of the bird and how the main cast shadow, which is solid black under the bird, becomes a lighter mid-tone along its length.

You can use various tonal values to lead the viewer through the image to the message you are trying to convey in your art. Here I have placed a dark shadow under the leopard to lead the viewer in the direction where the hapless meal might be.

The dark tones help to create the illusion of the leopard's body being three-dimensional. The dark shadow on the left grounds her and the reflected light on her belly helps to complete the trick.

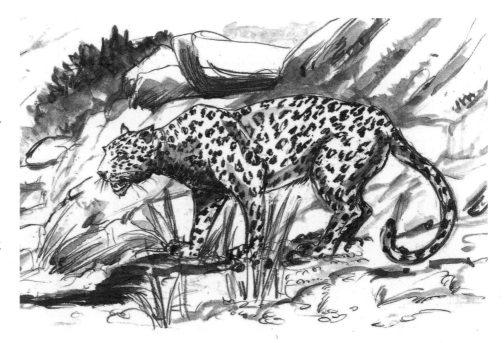

The Labrador watercolour called for a more subtle use of tones. There's the inherent tone of the dog's body and then various tones that create the idea of the soft coat. The slight suggestion of dark tone under the mouth and tongue helps the viewer to believe the depth of the mouth, while the lighter tone of the gums gives you the feeling that they are in front of the tongue. The highlights on the nose make it look as if you could reach out and touch it.

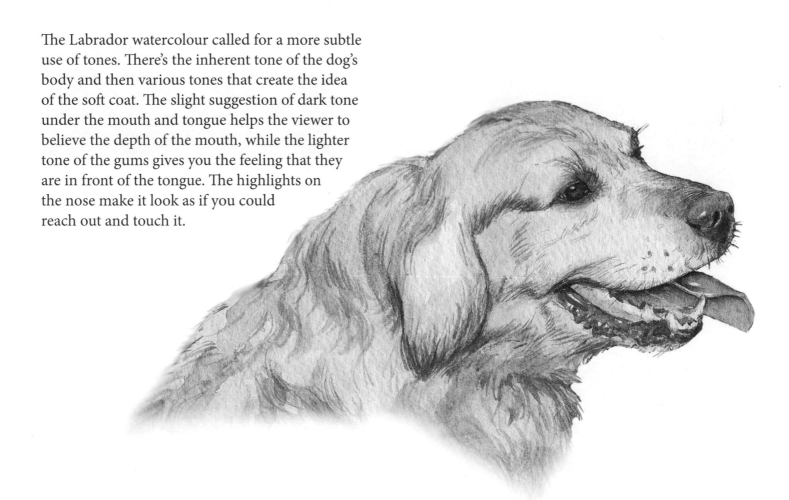

Toned and Textured Paper

Drawing on white paper means that you start making your marks on the lightest tone possible. Using toned or textured papers instead makes a change and is great fun. Toned paper allows you more time to work on your highlights and either mid-tones or dark tones, depending on the tone of your paper.

Chimp

First I pencilled in the head of the chimp, leaving the black of the paper blank to create his hair. A pale grey pastel pencil gave me the mid-tones around the face, leaving the dark of the paper showing through here and there. I used a black pastel pencil to add the blacks of the eyes, nostrils and mouth. Then I pulled the drawing together with a white pastel pencil to bring out all the highlights, including a rim light around the back of his head to separate him from the background.

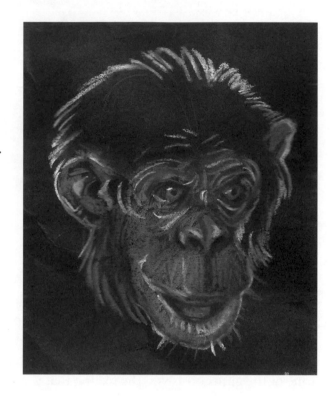

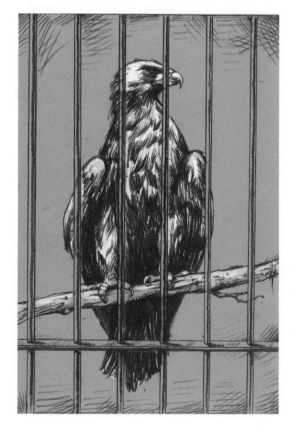

Eagle

The eagle is actually a black and white pencil drawing on regular white cartridge paper, but I thought I'd include a 21st-century version of toned paper using the computer. I scanned in the drawing and, using Photoshop, added another dark grey layer. With the eraser tool in the program, just like a real eraser or a white pencil, I started adding highlights to suggest the strong light source. It was quick and easy to do but very effective.

> *tip* Enjoy experimenting – you'll always have some 'happy accidents' and that's how you'll learn new ways of doing things.

Elephants

To demonstrate that you don't need special paper, I did this drawing on an old scrap of cheap photocopy paper. I drew with an 8B watersoluble sketching pencil and then quickly washed in some dark tones on the elephants, making the wash slightly wetter than I normally would to achieve a leathery texture. I blotted off the excess water with some kitchen paper and found it left some lovely textured lines.

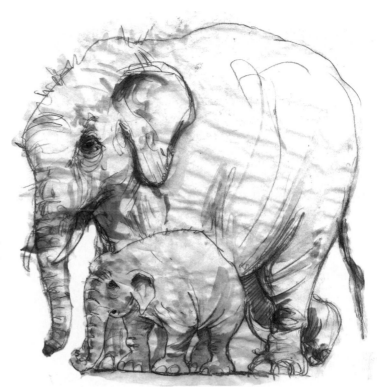

Bird

This little bird (below) was hopping about under our tree, trying to fly. We looked after him for a few days, after which he flew off – but before he did, I managed to make a few sketches of him. Here I used an 8B watersoluble sketching pencil on grey-toned paper, washing in the mid-tones lightly then finishing off with a white pastel pencil for the highlights. Only the initial drawing was done from life – he didn't stay still for long.

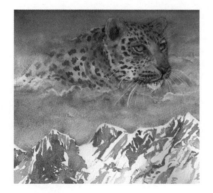

Leopard

This drawing, done some while ago as a cover for a book, is in watercolour on a heavyweight Rough watercolour paper. This has a textured surface that enhances the atmosphere in the painting.

Sparrow

I found this dead sparrow at the bottom of the garden, still intact. I thought it should be immortalized, so I pulled out my sketchpad, which has handmade paper with a rough texture to it. I set to work with my watersoluble pencil along with a brush and water to make washes. I tried to keep the drawing quick and loose and am especially pleased with the way the coarse texture of the paper enhances the drawing.

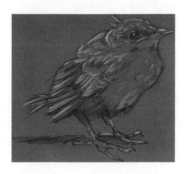

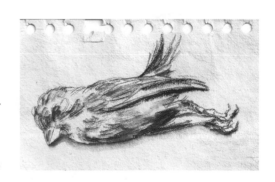

Graphic Cat Step-by-Step

This drawing shows what you can achieve using a burnt-out or over-exposed lighting effect. I found a picture of a black and white cat and started to do a quick sketch. Instead of doing a finished drawing I thought I'd make it more of a graphic image.

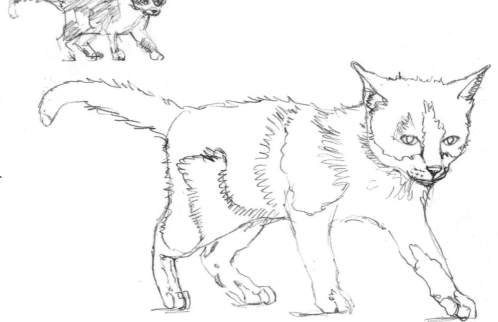

Step 1

I started by working out the areas that would be solid black and outlining these in pencil, referring to the little sketch that I did earlier where I quickly knocked in the tone. I also checked the reference photograph to follow the pattern on the head.

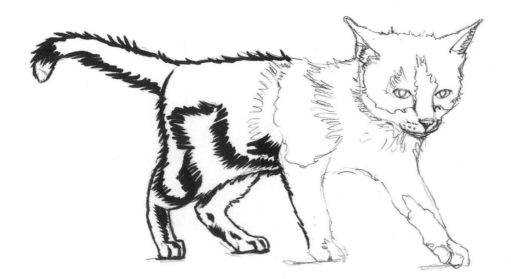

Step 2

Using my brush pen and marker pen, I started to outline the areas that would be solid black. I used the brush pen just as I would a brush, giving the patterns a jagged, furry look. I also started to ink in the legs.

Step 3

I finished off all the outlines and double-checked I hadn't missed anything. Before I began to fill in the cat's coat with solid black, I erased all the pencil lines so that I would have a clean, crisp image when I had finished. I started to fill in the black and went over one of the lines, using a little artistic licence to rearrange the pattern as I saw fit.

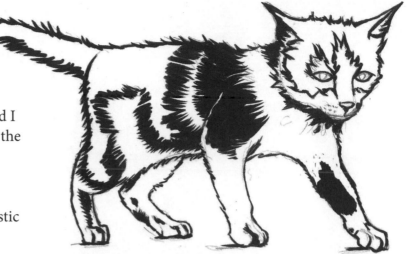

Step 4

As I painted in the black I changed some of the shapes. I didn't like the pattern on the front leg, so I stretched it up under the chest. This helps to fill out the body of the cat and give it more weight. I went over any black that looked patchy until it was completely black. Where there was black that I felt didn't look right, I simply painted over it with some white gouache. To finish off, I added some whiskers.

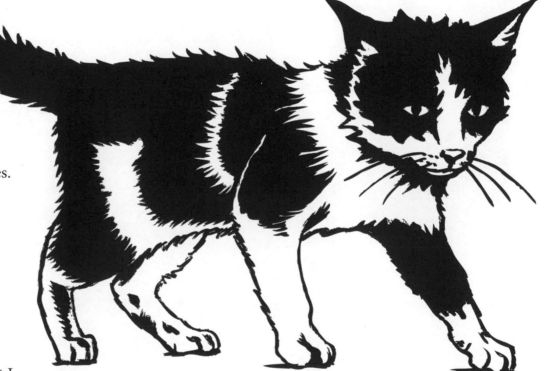

tip If you find your ink is bleeding over your lines on the paper you are using, buy a bleedproof marker pad – it's ideal for this type of work (see exercise on pages 118–119).

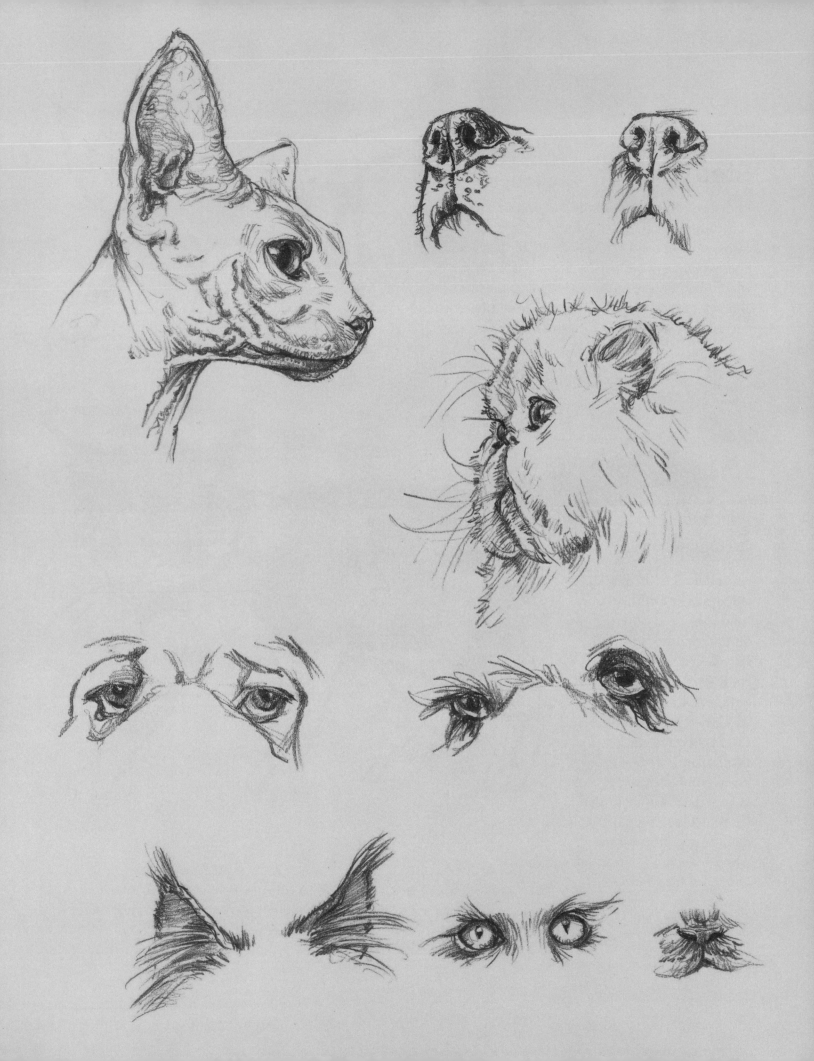

Chapter 6
Details

Over the next few pages we'll take a closer look at the details that identify our pets. By drawing different types of dogs and cats you'll discover how important it is to spend time looking at all the small details that help you to build up your knowledge of your pets as you put their likenesses on paper.

It's easy to see the difference between a long-haired and short-haired dog, of course, and you wouldn't mistake the head of a Pekinese for that of a German shepherd – but what you will want to look for when you're drawing your pets is what makes your own dog or cat distinguishable from all others of its breed and colour. This is much trickier, and is where close observation will really pay off.

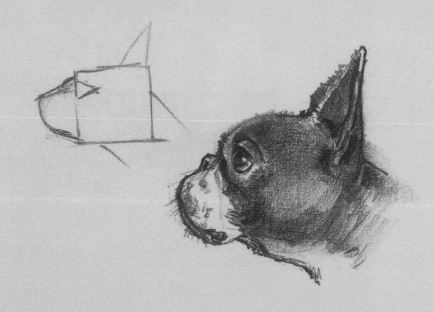

Dogs' Heads

While dogs come in all shapes and sizes, they have much the same characteristics when it comes to drawing them. Here are a few different dogs' heads, all easily drawn from the basic shapes shown on page 18 – then it's just a matter of adjusting them to suit the breed.

Use these heads as reference and make some quick sketches from them. Dogs are much more expressive animals than cats – their faces betray every emotion they have, so have some fun experimenting with that.

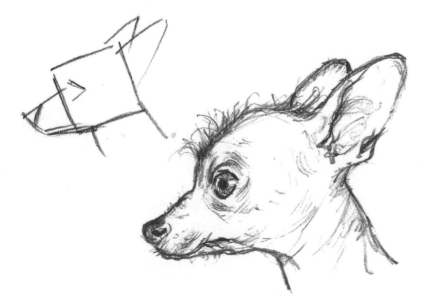

French bulldog pup

I used the side of the pencil to fill in the tone on his head and blended this in with my finger. I added in his highlights with my putty rubber.

Mongrel

This little dog was drawn with a 4B pencil, keeping the details to a minimum. I loved his unusual expression; he was great fun to draw.

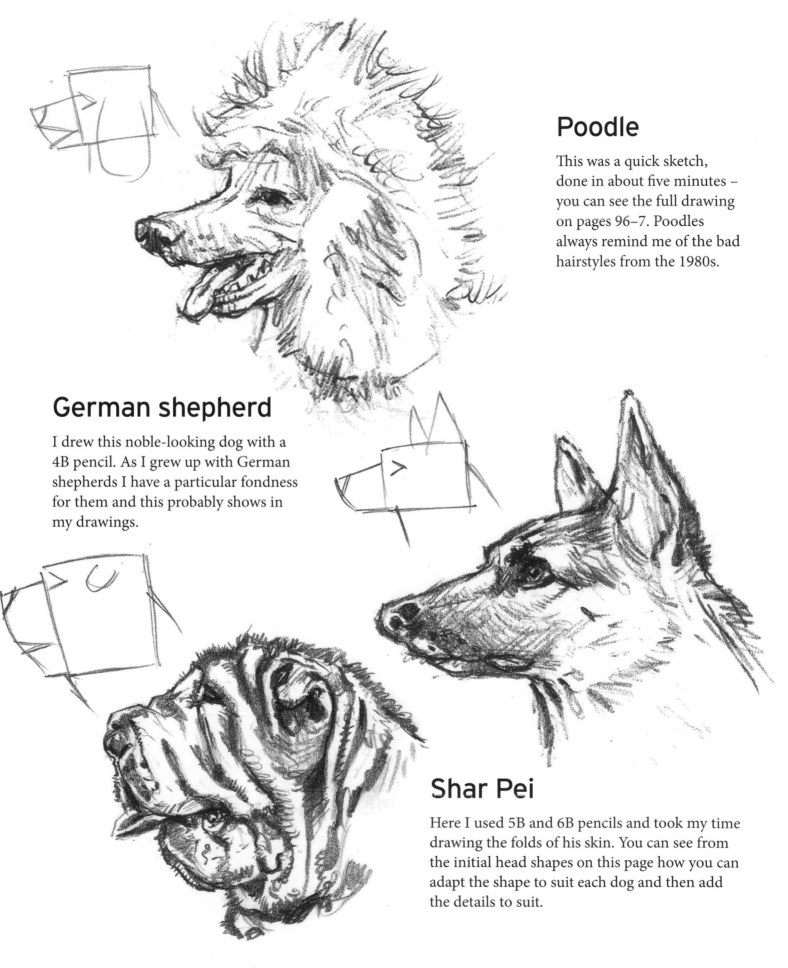

Poodle

This was a quick sketch, done in about five minutes – you can see the full drawing on pages 96–7. Poodles always remind me of the bad hairstyles from the 1980s.

German shepherd

I drew this noble-looking dog with a 4B pencil. As I grew up with German shepherds I have a particular fondness for them and this probably shows in my drawings.

Shar Pei

Here I used 5B and 6B pencils and took my time drawing the folds of his skin. You can see from the initial head shapes on this page how you can adapt the shape to suit each dog and then add the details to suit.

Dogs' Features

While features such as eyes and ears are basically the same within each breed, when you are drawing from your own models look for small identifying details such as a particular wisp of hair over the eyes or a little bit of ragged edge to an ear.

Eyes

Dogs' eyes display all their emotions – sadness, happiness, indifference, confusion and anxiety. When you are drawing your pet, try to capture those moments in your sketchbook so that when you come to do a more detailed drawing you will have a wealth of reference on hand. To capture every nuance of emotion, your camera will come in handy too.

Here's a selection of expressive eyes to give you a head start. Take a few minutes to copy these and then compare them to your own drawings at a later date.

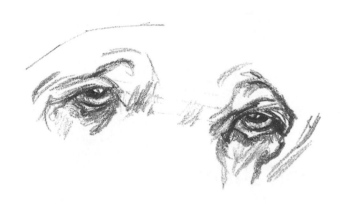

Basset hound

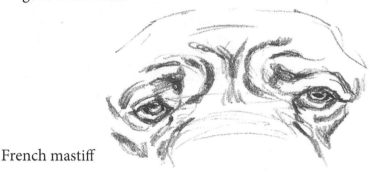

French mastiff

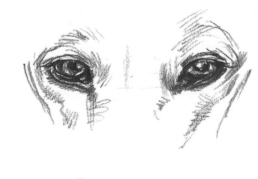

Borzoi

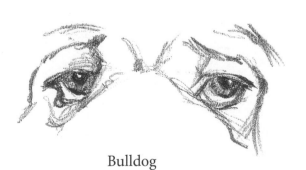

Bulldog

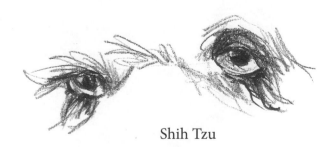

Shih Tzu

Noses

We have five million olfactory receptors in our nose that dictate our sense of smell; dogs have more than 220 million, which accounts for their extraordinary powers in this respect. I just love dogs' noses; they are great fun to draw. Take a look at these examples and then study the nose of a dog in life. Look closely at its shape, how it folds in on itself and the little vertical indent down the middle of the nose, called the philtrum.

Great Dane

Golden Labrador

Ears

Dogs' ears come in a variety of shapes and sizes – small, large, floppy or standing proud. Their hearing is far superior to ours, and the muscles in the ear flaps allow the dog to rotate them to locate where the sound is coming from.

Husky

Shih Tzu

Black Labrador

Bulldog

Cats' Heads

Although cats come in a variety of breeds, the difference between them is not as great as is found in dogs; from the everyday tabby to a pedigree Persian they are all essentially the same, except that they may have long or short hair and the nose and ear lengths also differ.

Materials and Equipment

- 4B and 6B pencils
- 220gsm (100lb) cartridge paper
- Putty rubber
- Pencil sharpener

Cats are wonderfully athletic animals and generally have beautiful oval eyes. While these are expressive, they are much more subtle than those of dogs.

Here are some examples of the differences found in cats' heads. Practise your cat-drawing skills by copying these and compare them to cats you know to see how different or similar they are.

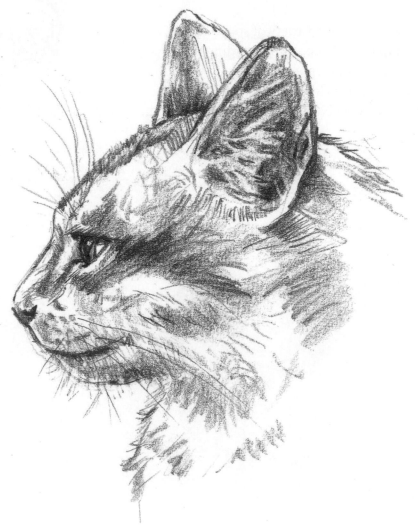

Long-haired cat

After using my 4B pencil for the main drawing I turned to my 6B pencil for the dark tone in the inner ear. I then erased lines with the putty rubber to suggest the white hair coming out. The highlights in the cat's eyes were lifted out in the same way.

Tabby

I left the underlying sketch showing through here and sketched in some tone with the side of the pencil to create the colour and pattern of the fur. The putty rubber again proved invaluable for lifting out highlights and making paler patches where needed.

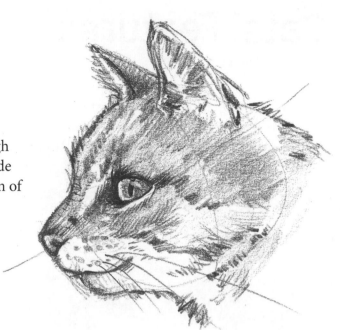

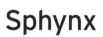

Persian

In profile, the nose on a Persian cat disappears into the fur. Because this cat was white I gave just a suggestion of tone on one side of his face and used it sparingly on the other.

Sphynx

While the Sphynx is a strong and beautiful cat, it's quite disturbing at the same time. I drew this fairly quickly and tried to keep it loose, with quite sparse lines to convey its lack of fur.

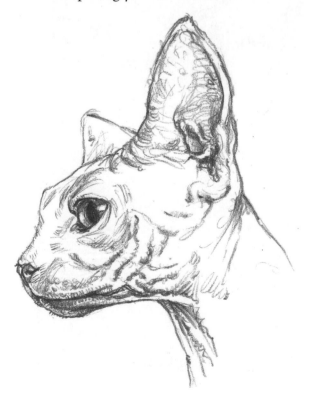

Cats' Features

The heads of the various cat breeds are mainly distinguished by the shape and size of the features rather than by overall size. Note the shape of the eyes in particular, since they make a big contribution to the cat's expression.

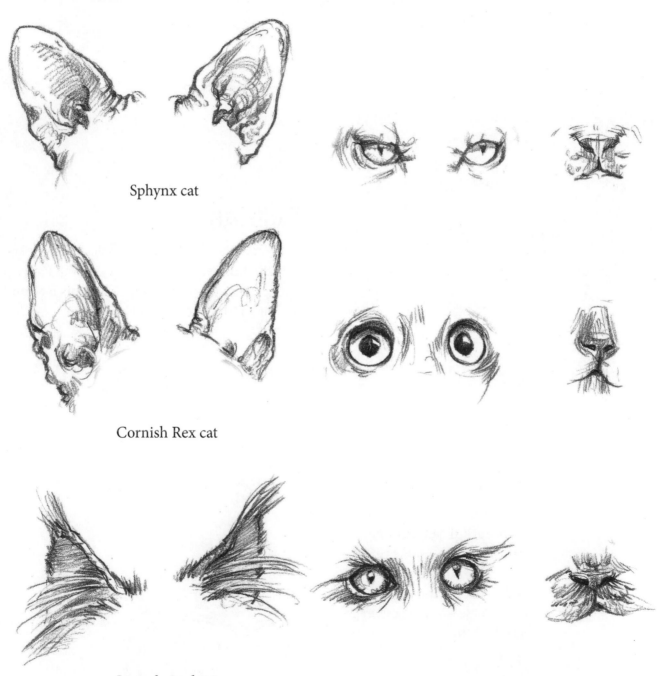

Sphynx cat

Cornish Rex cat

Long-haired cat

Other Animal Features

When it comes to other animals, there is of course such a wide difference in their features that there may be no resemblance at all between their ears, for example. As always, close observation of shape, tone and texture will see you through. With eyes, notice in particular how they are set into the head; in rodents, they often protrude. Predator species tend to have eyes at the front of their heads, while their prey have eyes at the sides, giving them a wide view of approaching danger.

Horse

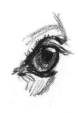

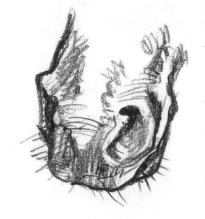

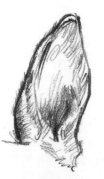

Rabbit

Guinea pig

Mouse

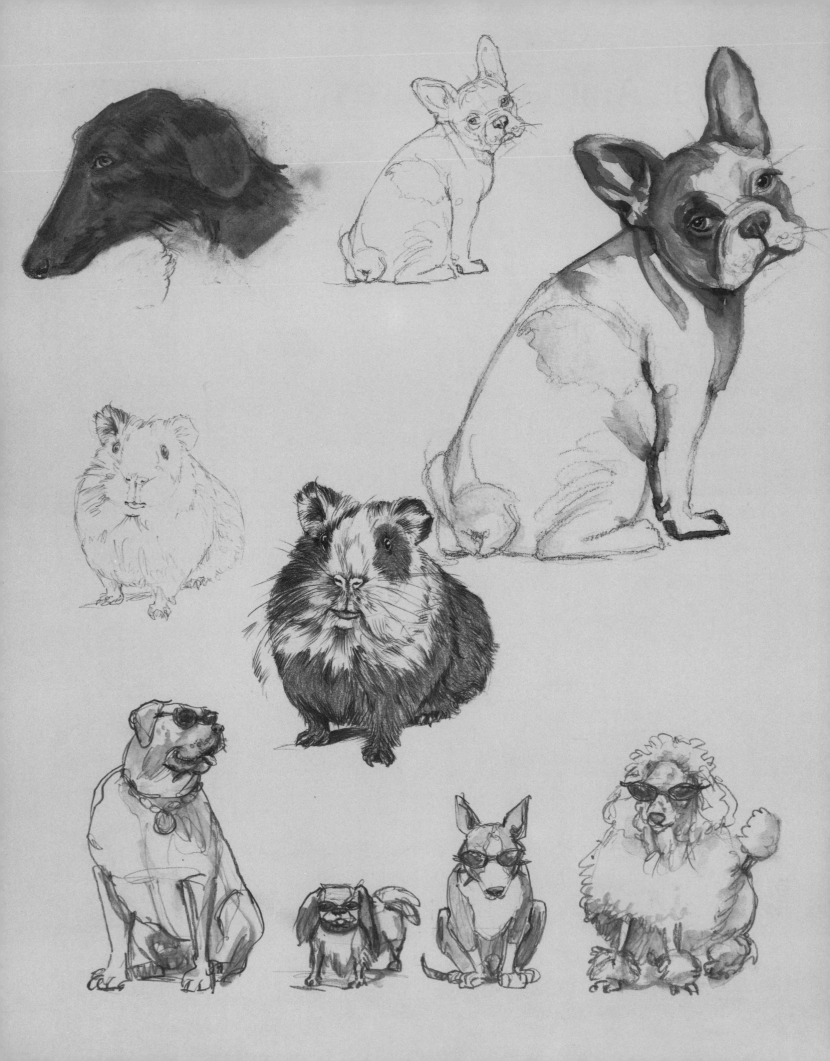

Chapter 7
Exploring Different Materials

Up to now we've been using just a few materials while you practise your early steps in drawing animals; here we'll compare some of the different types available for you to experiment with. Most artists develop a liking for a particular medium in which they feel they can express themselves best, so I encourage you to have a go at a range of materials so that you can find your own favourites and make educated decisions about which will most suit your subject and mood.

Work your way through this chapter and you'll discover that ink can give you highly detailed or very graphic images; charcoal can create wonderfully atmospheric and dramatic pictures; pastels offer vibrant colours; and watercolours will let you develop highly finished or diffuse washes.

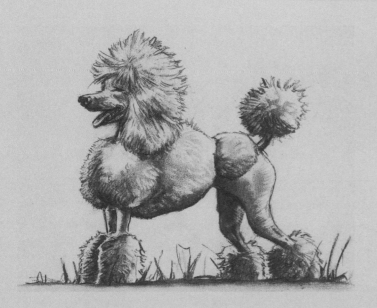

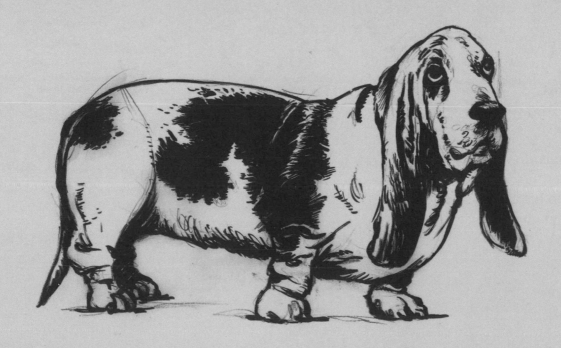

Ink

Applied by brush, dip pen or brush pens, ink can produce a clean dark line or solid black. As it can't be erased, you need a certain amount of practice to become comfortable with this medium – though if need be you can cover up mistakes with white ink or gouache. Here are some examples of ink drawings, showing the different effects you can achieve. Brush pens are a particular favourite of mine, and you will already have seen them used elsewhere in this book.

Here I used a brush pen and kept the line as fluid as I could, sweeping the fur lines away from the cat to suggest its movement. Because it was a black cat I also used a brush pen which was running out of ink to give it some lighter tone so that it didn't become a solid black.

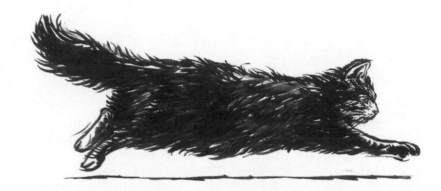

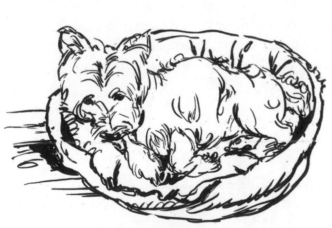

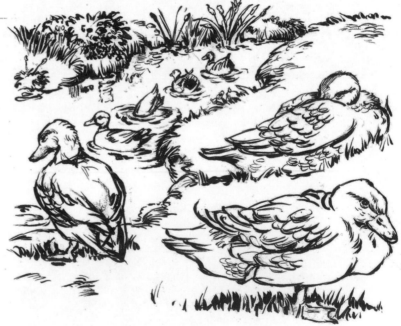

There was no underdrawing here – I tried to capture my dog Ted with a brush pen as quickly as I could before he moved! I kept the lines to a minimum to suggest only what was needed.

These ducks were drawn on location in pencil – I just sat by the river and did a quick sketch. When I got home I used a brush pen to ink in the drawing.

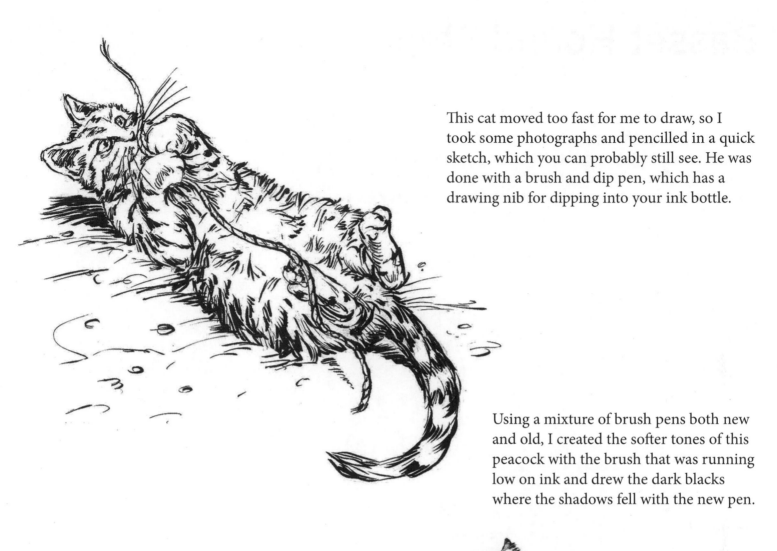

This cat moved too fast for me to draw, so I took some photographs and pencilled in a quick sketch, which you can probably still see. He was done with a brush and dip pen, which has a drawing nib for dipping into your ink bottle.

Using a mixture of brush pens both new and old, I created the softer tones of this peacock with the brush that was running low on ink and drew the dark blacks where the shadows fell with the new pen.

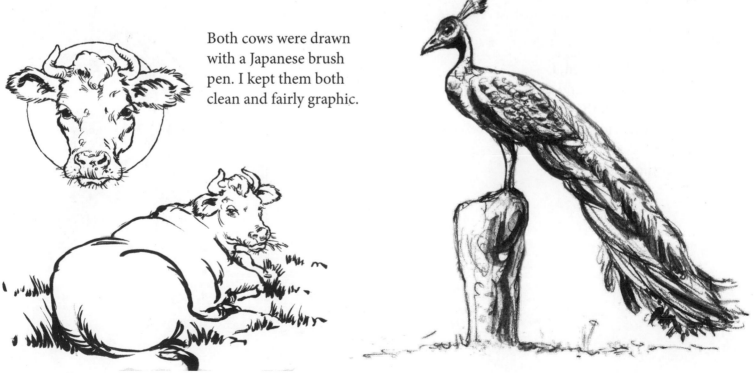

Both cows were drawn with a Japanese brush pen. I kept them both clean and fairly graphic.

Basset Hound Step-by-Step

I had always wanted to draw one of these dogs, so I thought I'd take the opportunity to demonstrate how a brush pen which has a brush at one end and a fine-liner (a fine fibre-tipped pen) at the other could be used to convey its loose skin and patches of dark fur.

Materials and Equipment

- 4B pencil
- Putty rubber
- 220gsm (100lb) cartridge paper
- Black brush pen with brush at one end and fine-liner at the other
- White gouache

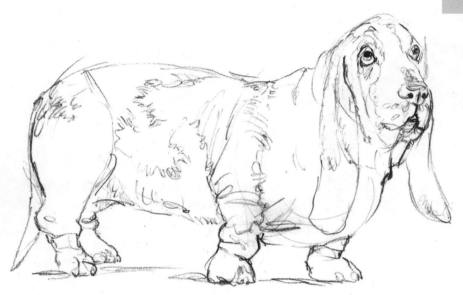

Step 1

I did a quick sketch of this basset hound using a 4B pencil, simplifying the dog's coloured pattern which I would block in later with black.

Step 2

With the black brush pen, I filled in the shapes around the eyes and worked on the ears. My intention was to keep this drawing very graphic, almost eliminating any mid-tones.

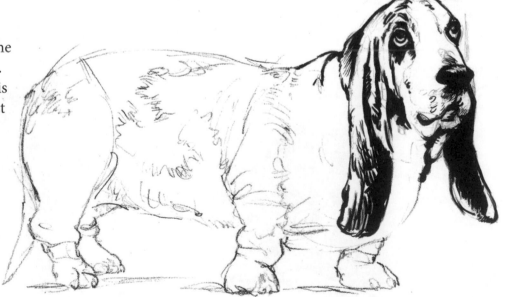

Step 3

I've now filled in the black pattern and inked in the rest of the dog, using both ends of the brush pen. I added thinner lines to give the feeling of the hairs on the dog's coat hitting the light.

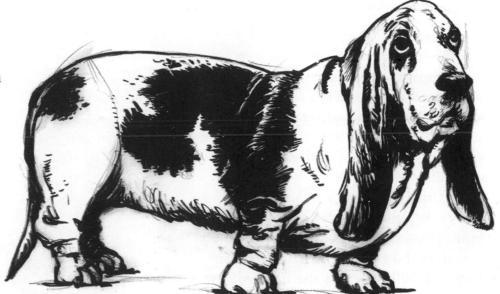

Step 4

Here's the final image, with all of the pencil lines erased. That's one of the advantages of using ink – when it's dry all the unwanted guidelines can be removed. I also realized I'd blacked in one of the eyes, so, using some white gouache, I added the highlight and also put in some more white on the nose.

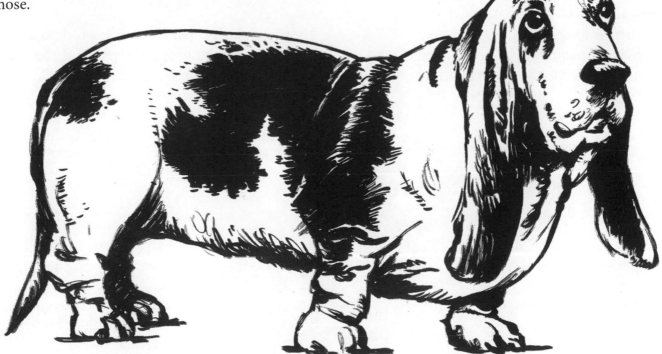

Watercolours

It takes a lot of patience and experimentation to master watercolours – I've been using them for over 25 years and I'm still learning! But watercolour is a great way to make your drawing come to life and it will be easier to handle if you follow a few basic rules.

The first is to work on fairly heavyweight watercolour paper. This comes in pads or individual sheets; I recommend a Bockingford watercolour 300gsm (140lb) pad. As the name of the medium suggests, you'll be using water, so you need a paper heavy enough to hold the wash without buckling.

In watercolour you always work from light to dark, building up your washes of colour (or in our case greys) one after the other, finishing with your darkest tones. Watercolour is a light and bright medium, but it can also give you deep dark shadows and a detailed painting if you so wish. Shown here is a variety of watercolour pictures, from the fully rendered to the light and breezy wash type.

The parrot was a detailed painting which took a lot of time, as I had to build up the layers of washes. I lifted out a lot of the highlights using a brush and water and tissue. The feathers on the wing and tail were achieved using wet-into-wet technique, with some of the highlights added with white gouache once the watercolour was dry.

The kitten was painted fairly loosely, though I took my time to work on the details in the basket.

For this mouse I used an 8B watersoluble sketching pencil, drawing quickly but paying attention to detail on the head and paws. I then used a brush and water to create the wash.

Exploring Different Materials

In the painting below I used wet-into-wet technique. After the initial sketch, I covered the image with water and while it was still wet I added the tones, gave them a minute to partially dry, then added the next tones. This allowed the paint to gently bleed together, giving this nice soft feel.

This German shepherd dog was drawn with watersoluble pencil followed by washes of water, but while the washes were still wet I added more pencil lines – almost the classic wet-into-wet watercolour technique of dropping paint into a previous wash that is not yet dry. Don't be too precious with your work – experiment freely, since you never know what you might come up with.

My line-up of dogs wearing sunglasses was done with a watersoluble pencil. It was very quickly drawn and washed in as I wanted it to stay fresh and light.

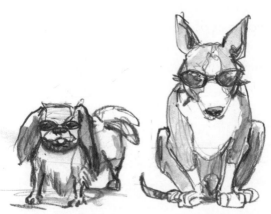

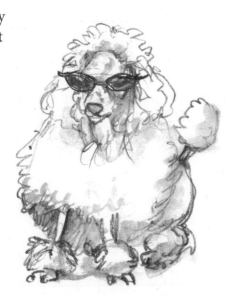

French Bulldog Puppy Step-by-Step

As soon as I saw this little dog I knew I had to draw him – I couldn't resist the tilt of his head and those eyes.

Materials and Equipment

- 3B pencil
- Bockingford 300gsm (140lb) watercolour paper
- Putty rubber
- Neutral Tint artists' watercolour
- Watercolour brush, No. 8 round

Step 1

I began by drawing the puppy with a pencil, first the outline and then some head details.

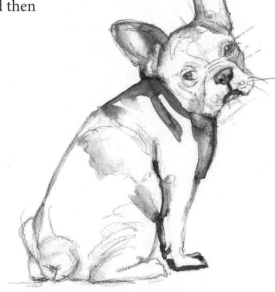

Step 2

Next I mixed up some Neutral Tint, which is a dark, almost black grey, loaded my brush and started to block in most of the toned areas, which were the darker patches on the dog's coat and a suggestion of an outline. I kept the brush flowing, blotting up any unwanted areas of paint with a tissue. I used a clean damp brush to lift tone which I thought at this stage was too dark. I then blended some of the tones together with a damp brush.

 When you're adding wet washes to your work, make sure you have a tissue or a sponge ready to mop up any unwanted drips or spillage.

Exploring Different Materials

Step 3

In the next stage I started adding darker washes around the back of the ears, the top of the eyes and the nose. I loaded my brush with more colour and painted into the dark lines and then, very quickly, before the paint had a chance to dry, I used a damp brush to blend in the tones so that they weren't too strong and stark. I worked mostly on the head, firming up the dark tones, and then turned to the eyes. The iris was a medium dark, and then when that was dry I put my darkest black tone in the pupil. I took care here to keep the highlights in the eyes free and clear of any paint, but if I had made a mistake I could have touched them up later with some white gouache.

Step 4

Now I started to work on the body. I filled my brush with the darkest tone and drew a line down the back of the hind leg, almost like an outline, then I cleaned my brush, filled it with water and pulled it gently down, just touching the line. This gave a nice graduation and helped to give shape to the spine. I did similar brushwork around the front and hind legs, all the time adding more dark tone and adding a wash of water to blend it in. I quickly suggested the tail – I tried to keep this piece fresh and detail-free, apart from the head.

I then reinforced some of the shadows and put darker lines around the ears and eyes. Next I painted the patch on his back, first putting a damp wash on the shape and then adding a loaded brush with mid-tone on top. This resulted in the colour bleeding and creating a slight highlight on top. I pulled off some of the colour with a dry brush to suggest the hairs of the dog's coat. I liked this, so I did the same thing on the head, eye and tail.

Charcoal

You'll find that charcoal is a great tool for drawing, since it can not only give wonderful rich blacks but also beautiful subtle tones. This makes it a very versatile medium and one that I hope you'll enjoy using.

Before you start a complete drawing, do some quick sketches first to familiarize yourself with using the charcoal sticks. When you want to add fine detail, use the point of the charcoal stick; for covering areas with tone, work with the side of it. This way you'll see the different marks and subtle tones that can be achieved. Charcoal can be very messy but very rewarding – it just takes a little care and planning first. When you have done a drawing you're pleased with, spray it with fixative bought from an art supplies shop so that it doesn't smudge.

Poodle step-by-step

The woolly coat of a poodle lends itself well to treatment with charcoal to convey its softness and density.

Step 1

First I did a very basic sketch of the poodle with a 3B pencil to make sure I got the shape right.

Materials and Equipment

- 3B pencil
- 220gsm (100lb) cartridge paper
- Willow charcoal sticks, medium-hard
- Dark charcoal pencil
- Putty rubber
- Watercolour brush, No. 2 round

Step 2

I broke a stick of willow charcoal in half, which makes it more manageable to use and gives you a sharp edge for detail. Checking my reference picture, I began to follow where the shadows and tones were and drew these in. Where the dark shadows were I made these marks heavier and then, with my finger, smudged them towards where the light was falling to create the blend of tone. You can use something called a smudge stick to do this, but I prefer to get my hands dirty.

Step 3

I started to add detail in the face by using the charcoal stick and charcoal pencil. Next I blended all the areas on the body and put in some details to the hair and head, using the putty rubber to lift out light areas. I also created a light area under the near hind leg to give a suggestion of the light hitting it and lifted out the highlights on the dog's coat. With the fine end of the charcoal stick, I drew some lines around the body and hair.

Step 4

I decided to add a dark background to emphasize the whiteness of the dog's fur. To do this I drew a heavy black outline carefully around the dog with a charcoal stick, then, with a paintbrush, start to dust away from the line, creating a dark tone behind the dog. I took care not to go right up to the line with my brush otherwise it would be lost.

Step 5

My final task was to lift out any details in the hair and any areas that looked smudged. I also noticed that I had lost the dog's neck! Mistakes such as this often happen when you get caught up in your work, which is why you should keep stepping back from it to assess it. I used the putty rubber to draw in a new neck and also altered the front leg so it now sits better under the body.

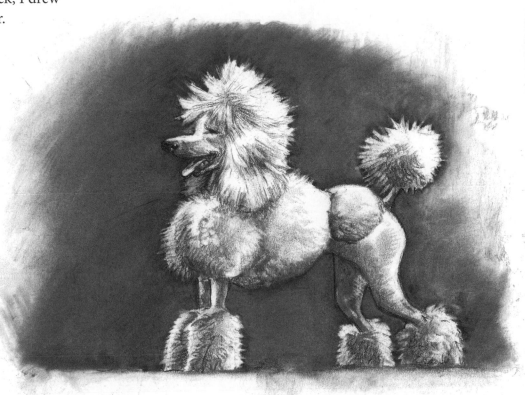

Guinea pig step-by-step

While guinea pigs have very long, dense hair, it falls very neatly, making the job of the artist easier. This is a mixed media drawing, with charcoal to suggest the colour of the fur and pencil for the final drawing and details.

Materials and Equipment

- 4B pencil
- 220gsm (100lb) cartridge paper
- Dark charcoal pencil
- Pencil sharpener
- Putty rubber

Step 1

A couple of oval shapes helped me to form the little doodle guinea pig, and once I had done this I was ready to move on to the bigger version. I started with the pencil and a light outline of the same shapes, then sketched in all the main parts, using my doodle and photograph as reference. I then erased all the guidelines, quickly suggested the flow of the hair and started adding detail on the left ear.

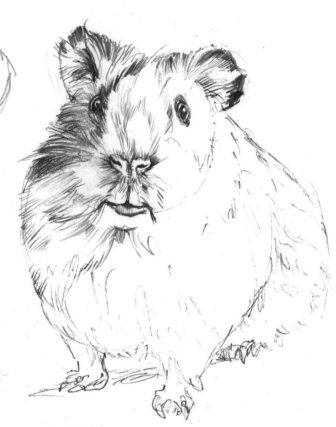

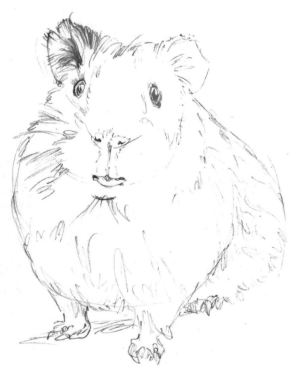

Step 2

Next I set to work on the eyes, as I like to establish these early on. With them put in to my liking, I used very definite lines to depict the flow of the hair, following the animal's shape to create a realistic look. I spent some time on the nose and mouth, as these are the main focus of the piece.

Step 3

I now added darker lines under the chest and legs, which are shaded from the light. Following the pattern of the hair, I began filling in the legs and then drew in the feet and claws. I put some fine lines around the eyes then reinforced the lines under his lip. Next, with the charcoal pencil, I drew in some tone in his coat to represent the colour, taking care to leave some white hairs overlapping the tone. To blend in the darker tone, I dabbed some of it off with a tissue. I worked on the rest of the body in the same way, finishing at the feet.

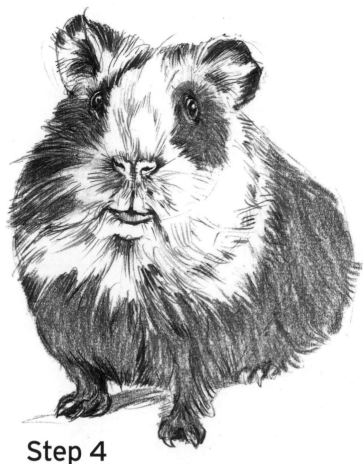

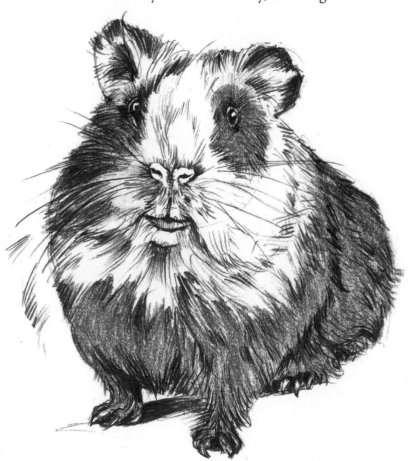

Step 4

With all the colour tone in place, I turned to his shoulder and picked out the darker shadow lines with the 4B pencil. I built up more fine lines on the hind leg, then added details in the claws and some whiskers. With the putty rubber, I cleaned the highlights in the eyes and around the nose. I finished off with a suggestion of shadow under the leg and chest with the pencil and charcoal.

Tip Before you start a drawing, do some warm-up exercises. Start with some doodles of whatever pops into your head, just to get your hand relaxed. Then do a rough sketch of what you're about to draw and there you have your quick doodle to work from.

Pastels

For many artists, pastels are a great medium because they can be used to create highly finished pieces or vibrant impressionistic work; Degas, Renoir and Toulouse-Lautrec are among those who worked extensively with them. They come in three types: soft, hard and oil pastels. For the demonstrations here I used soft pastels.

Materials and Equipment

- Pastel pencils
- Soft pastels
- Ingres pastel paper pad
- Charcoal pencil
- Watercolour brush, No. 2 round
- Putty rubber
- Pencil sharpener/craft knife

Pastel cat step-by-step

I decided to use a rather rotund feline friend with plenty of soft fur for this pastel demonstration.

Step 1

I began with a quick sketch done in pastel pencil to get the shapes down on paper.

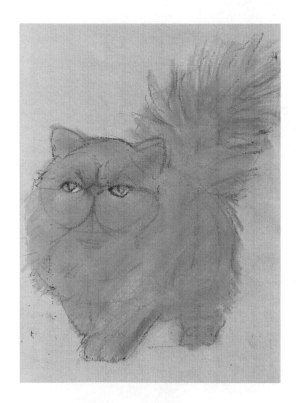

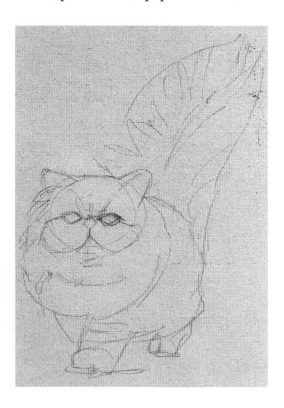

Step 2

Next, with a mid-tone pastel, I filled in the whole image, taking my time on the tail and following the shape of the long fur.

| Exploring Different Materials

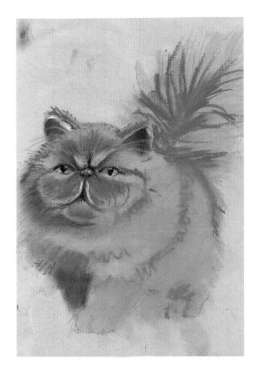

Step 3

Here I started to blend the mid-tones using my watercolour brush. With a slightly darker-toned pastel, I added the fur around the face and tail section. I started on the eyes with a charcoal pencil and added detail, then darkened the inner ears with my darkest pastel.

Step 4

After adding more detail all over to suggest the hair of the cat, I worked over the dark and mid-tones with a white pastel to add the highlights, using alternately pastel pencils and pastel sticks to do this job. Finally, I darkened some of the areas that had been smudged and then tightened up the eyes, nose and brow area. Those were the only parts where I wanted detail – the rest was kept loose.

Tip When you've finished your pastel or charcoal drawing you can spray it with fixative to stop it smudging. Do this out of doors to avoid inhaling it, as it is toxic.

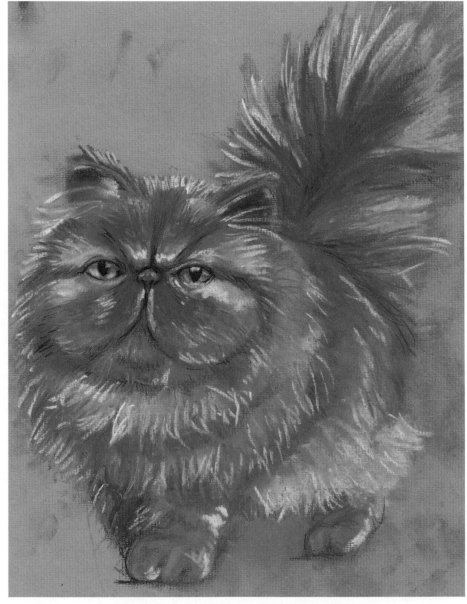

Russian Borzoi wolf-hound step-by-step

This drawing shows a slightly more detailed use of pastels compared to the cat exercise on the previous pages.

Step 1

Using a black pastel stick, I started with a basic outline of the wolfhound's head. I sketched in the eye and a hint of where I would be adding tone, smudging it on with my fingers.

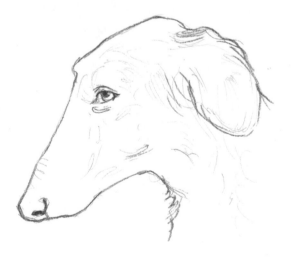

Step 2

I covered the whole image, apart from the area under the chin, which would stay white. Then, switching to a black pastel pencil, I defined the area around the eye and nose and drew in the shape of the dog's face where the tone would be dark. This started to give the impression of the dog's skull beneath the skin.

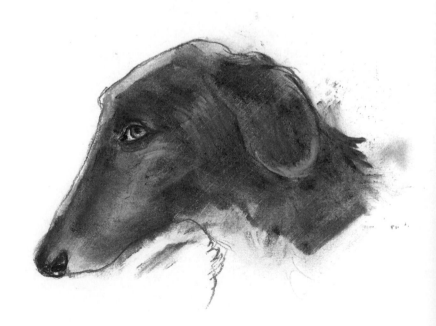

Step 3

Next I blocked in the tones of the dog's coat and began to show the flow of the hair on the cheek and ear. Using a mixture of pastel sticks and charcoal, I made the dark tones even darker, especially under the ear, neck and cheek. With my watercolour brush, I lightly removed some of the pastel tone to create the lighter shades next to the cheek and ear.

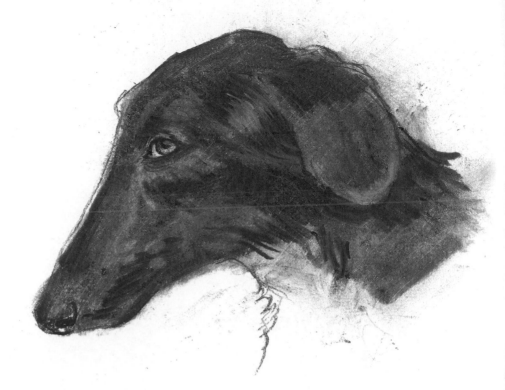

Step 4

To get a feel for the dog's coat, I switched between charcoal and pastel pencils to give the dog whiskers and stray hairs at the top of his head, then suggested the curls of the coat in the same way. I used a white pastel for the neck and went over it here and there with a grey pastel to give it some tone for shadows. The pupil of the eye had been smudged at some point, so I redid the highlight. Lastly, I used my putty rubber to clean up some of the mess I had made around the dog's head.

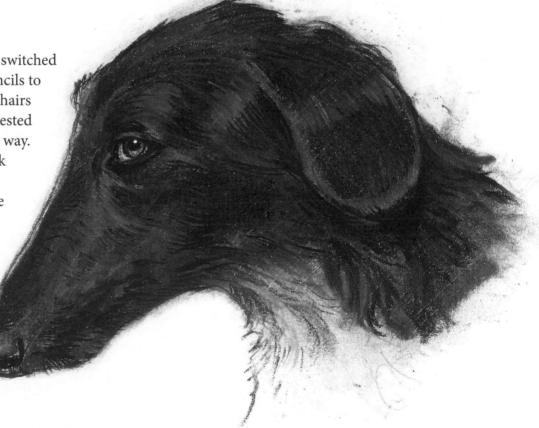

Chapter 8
Composition and Pet Portraits

As your drawing skills improve and you gain confidence, you'll want to embark on more ambitious drawings. This will mean that you may want to include people in the portraits of their pets, and you may also like to tackle settings in which to place them. Here you'll come to the subject of composition, where you have to work out how to make a picture that's pleasing to the eye in itself, not just for the drawing of the animal contained in it. For more elaborate and finished drawings, I recommend doing some gesture sketches first, as a sort of loosening-up exercise and as a way of starting to familiarize yourself with your subject. It's also a good way of building up a library of reference sketches.

In this chapter you'll find some drawings where pets have been joined by their owners. I've concentrated on just the individuals with no background distractions so that for the time being you needn't worry about trying to get a background working well with the foreground – but notice the overall shapes that are to be found in these drawings and the visual clues that will pull the viewer's eye where you wish it to go. You will already be assembling the building blocks that can be expanded into more complex compositions.

Composition

Whenever you draw a scene, rather than just a study of a subject, you have to take decisions about what to put where. Composition simply means deliberately arranging all the elements that are included in order to create a pleasing picture. Some artists who are just starting out find this a bit daunting, but although you might not have realized it, you use composition every day: for example, when you speak to a group of friends you compose your view as to who should be your focal point, and when you take a photograph you unconsciously select your composition. So you probably already know more about the subject than you think.

Triangle-shaped composition

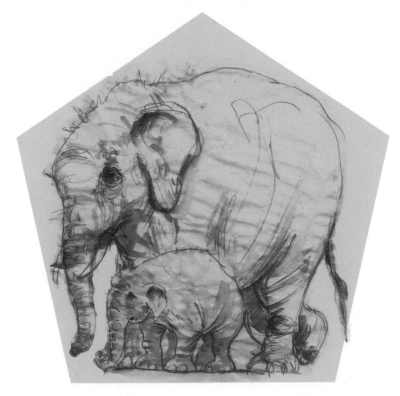

Pentagon-shaped composition

There are many different types of composition as far as an artist is concerned. In classical composition, the objects in an artwork are arranged in a particular pattern that helps to guide the viewer's eye around the painting or to the focal point of the piece. One of the most popular devices for doing this is a triangle shape, though almost any geometric shape is valid. Obviously, the shapes that you'll create using the elements in the picture won't be visible in the final drawing, but their placement will give your final composition a solid grounding. This will help to tell your story to the viewer.

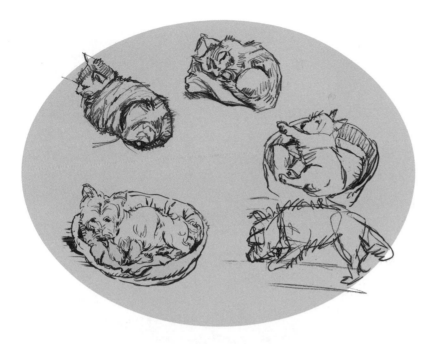

Oval-shaped composition

One of the easiest ways of composing a picture is to use a small frame cut out of card. You can make one of these yourself or buy a ready-made mount from your local art shop. Hold up the frame between you and your subject matter and then simply move it around until you find your perfect composition within the frame.

Remember that you can move elements around in your picture before you decide on the final version – one of the main differences between taking a photograph and making a drawing is that you don't have to settle for what's there. If something is in the wrong place, you can choose to put it somewhere else!

Using the frame helps you compose your picture

Gesture Drawing

Gesture drawing is like doing a warm-up exercise before you run a race. It will help you to loosen up your arm and, most of all, it will change how you normally draw. A gesture drawing should be kept short, lasting up to about two minutes or less. You have to try to capture the essence of your subject, the feel of the animal in front of you – it's not about details, just the spirit of drawing.

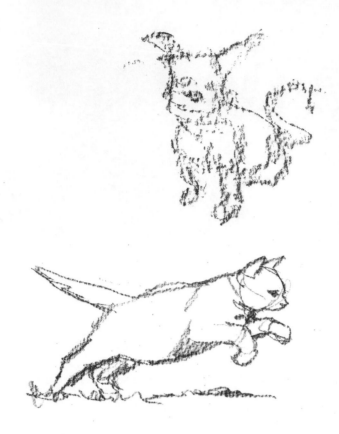

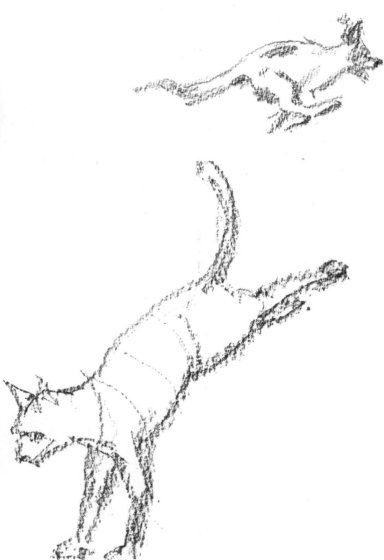

So, set yourself a brief time limit and stick to it. Before you start, observe your subjects for a while, note how they move and then go for it, trying to keep your eyes on the subject rather than your drawing pad. The idea is to follow the flow of the animal, so that your drawing echoes it. Keep your hand and wrist loose and hold your pencil lightly.

Here are some two-minute gesture sketches I did. As you can see, there's very little detail in these images – all I tried to do was capture the movement and feel of the various animals.

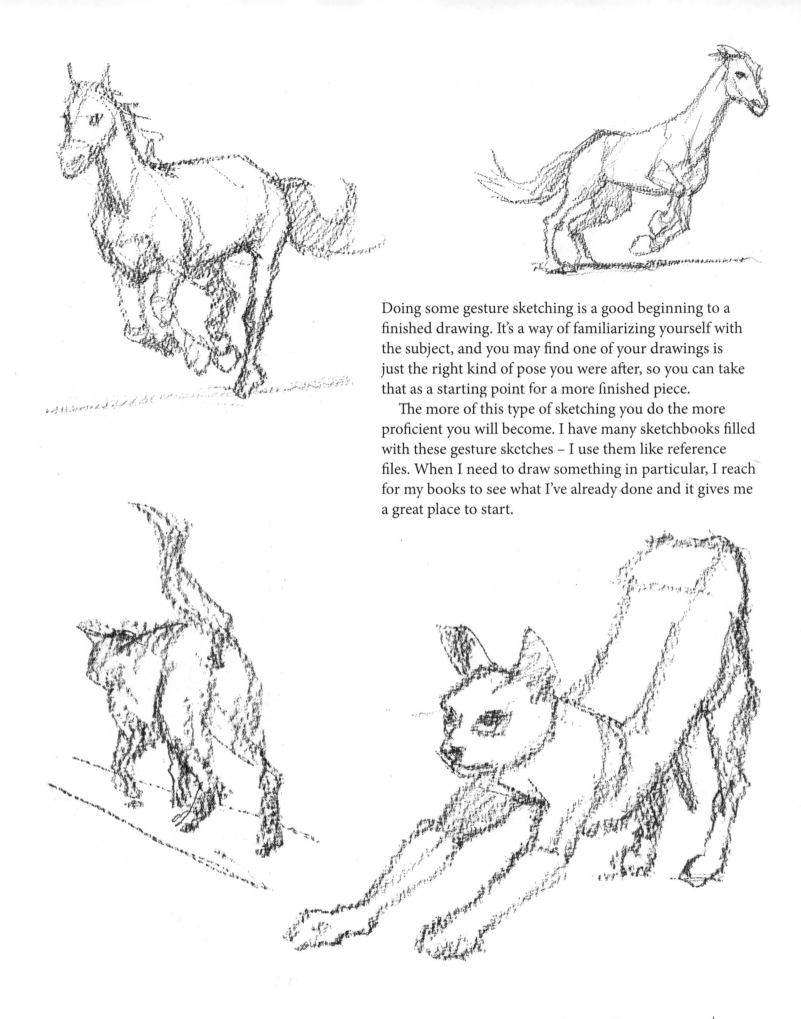

Doing some gesture sketching is a good beginning to a finished drawing. It's a way of familiarizing yourself with the subject, and you may find one of your drawings is just the right kind of pose you were after, so you can take that as a starting point for a more finished piece.

The more of this type of sketching you do the more proficient you will become. I have many sketchbooks filled with these gesture sketches – I use them like reference files. When I need to draw something in particular, I reach for my books to see what I've already done and it gives me a great place to start.

Pet and Owner Step-by-Step

I liked the difference in scale here and the eye contact made between the owner and dog – it was a fun drawing to do.

Materials and Equipment

- Dark charcoal pencil
- 140gsm (60lb) acid-free paper
- Pencil sharpener
- Putty rubber

Step 2

I wanted the drawing to have a light feel to it, so I drew the figures loosely, working fast and trying not to get bogged down in detail.

Step 1

I doodled a little rough sketch to work out the composition. Once I was happy with that, I put it to one side and started afresh.

Step 3

I started to work on the dog's head, adding detail to the eyes, but still trying to keep this as a finished sketch rather than a finished drawing. Then I drew the man's head, suggesting tone, but letting it fade off. I did the same with his hair, drawing in the tone but leaving white spaces to create the rest of the image.

Step 4

I noticed that the man's head was a bit small at the back, so I added more hair to fill out the head shape and suggest the back of the skull. Then I turned my attention to finishing off the rest of the drawing. I added the tone of the dog's coat between the fingers, then added more tone to the edge of the hand to bring it forward, giving the appearance that it's holding the dog. I lightly indicated the rest of the drawing, then I had finished.

Rabbits Step-by-Step

With their sleek fur and long ears, rabbits always make an appealing subject for a drawing. They come in a range of breeds, too, some with drooping ears, attractive markings or very long fur, so there's a wide choice to try.

Materials and Equipment

- 3B, 4B and 6B pencils
- 220gsm (100lb) cartridge paper
- Putty rubber
- Pencil sharpener

Step 1

Using a 3B pencil, I did a quick little doodle to work out the shape of the rabbits. Happy with that, I moved on to the bigger version, creating a quick outline with all the features added.

Step 2

With light shading, I suggested the pattern on the rabbit at the back, then I switched to a 4B pencil and added detail to the eyes and nose. I switched to a 6B pencil and turned to the foreground rabbit, drawing in the dark of the eyes, nose and mouth. I returned to the 3B for the finer lines, building up the texture around the head and ears, then used the 6B for the dark areas around the ears.

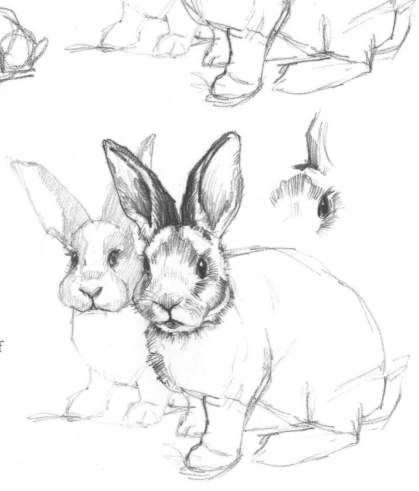

Step 3

Next I used my pencil lines to suggest the texture of the coat, following the contours of the body and using 3B and 4B pencils. I left the white of the paper showing here and there to give the impression of light on the body.

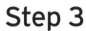

Step 4

Now I set to work adding more detail to the rear rabbit, keeping the strokes lighter to show that it is a little further away from the viewer. I used a combination of the pencils to darken the head slightly and keep the rest of the body fairly light. After that I went over the whole drawing, adding darker lines where needed. Using the putty rubber, I tidied up the highlight in the front rabbit's eyes and cleaned up any other areas that had been smudged. Finally, I added some whiskers and I was done.

Girl and Yorkie Step-by-Step

I used a photograph I took of my daughter and one of our dogs for this demonstration, but I found I had to stop myself getting too caught up in trying to get her likeness right instead of concentrating on the whole picture. This is one of the dangers of drawing someone you know.

Materials and Equipment

- 8B watersoluble sketching pencil
- 220gsm (100lb) cartridge paper or Not surface watercolour paper
- Putty rubber
- Pencil sharpener
- Watercolour brush, No. 8 round

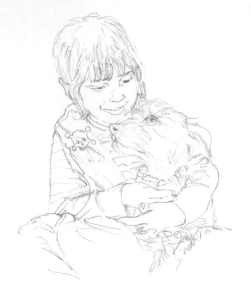

Step 1

First I used my watersoluble pencil to draw an outline of the figures, paying close attention to my reference.

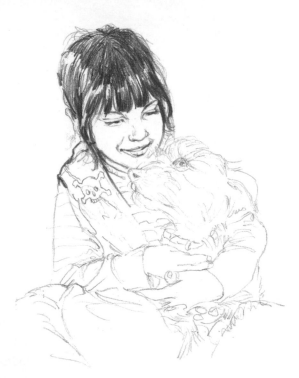

Step 2

After that I started laying down the darker tones in the hair, keeping in mind where the highlights would be.

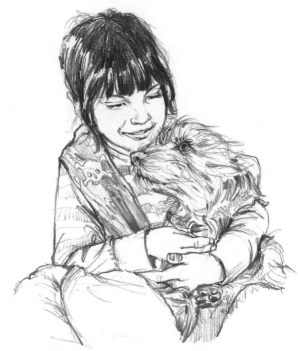

Step 3

Next I worked on the rest of the drawing, darkening the tones as I went. I added details to the central area and left the outer parts to fade out so that the central focus is on the dog and the girl's head. Then I gently filled in the tone on the clothes.

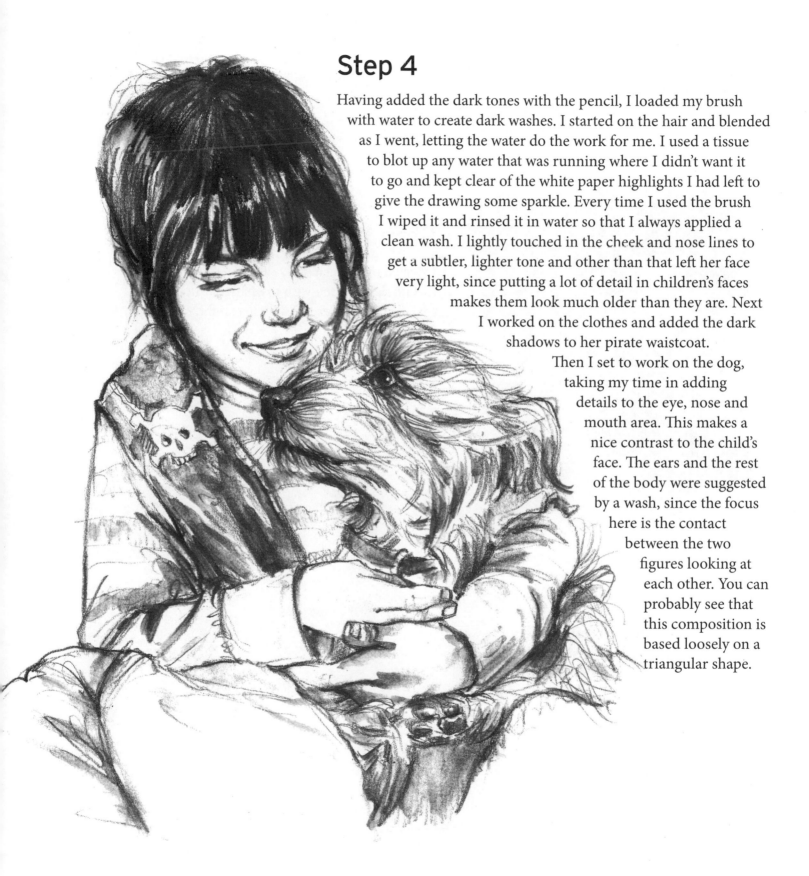

Step 4

Having added the dark tones with the pencil, I loaded my brush with water to create dark washes. I started on the hair and blended as I went, letting the water do the work for me. I used a tissue to blot up any water that was running where I didn't want it to go and kept clear of the white paper highlights I had left to give the drawing some sparkle. Every time I used the brush I wiped it and rinsed it in water so that I always applied a clean wash. I lightly touched in the cheek and nose lines to get a subtler, lighter tone and other than that left her face very light, since putting a lot of detail in children's faces makes them look much older than they are. Next I worked on the clothes and added the dark shadows to her pirate waistcoat.

Then I set to work on the dog, taking my time in adding details to the eye, nose and mouth area. This makes a nice contrast to the child's face. The ears and the rest of the body were suggested by a wash, since the focus here is the contact between the two figures looking at each other. You can probably see that this composition is based loosely on a triangular shape.

Spaniel Portrait Step-by-Step

This is probably one of my favourite drawings as it was so easy and pleasurable to do. Sometimes a drawing will practically draw itself, and this was one of those.

Materials and Equipment

- 8B Derwent watersoluble sketching pencil
- Rough surface tinted paper
- Putty rubber
- Watercolour brush, No. 8 round
- White pastel pencil

Step 1

I started by doing a fairly detailed drawing of this noble little dog with my pencil. The Rough surface paper gives the sketch a slightly uneven feel, which I liked.

Step 2

I used my brush to add some water and started to soften the lines on the nose to create a nice wash of tone. I continued this around the eye, taking my time to make sure my wash went exactly where I wanted. I did some initial work on the mouth, too.

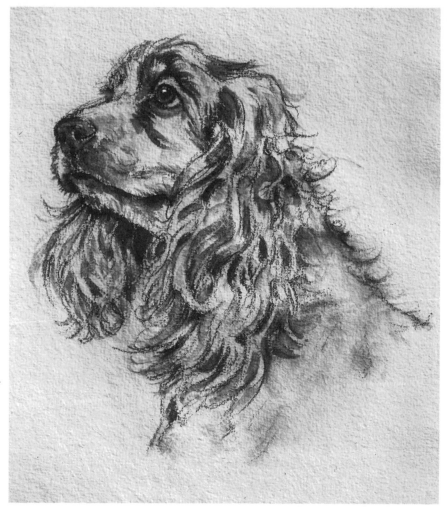

Tip Always remember to work from light to dark when you are using watersoluble pens and watercolour paints as you can always add darker washes later. If you do those first you may have problems removing them to create a lighter area.

Step 3

Next I created the tones in the eye and surrounding areas by adding more washes of water. I started to lose the black of the pencil line, so I took a separate sheet of paper and scribbled a dark tone on it. Then I washed a slightly damp brush into that, which gave me a dark wash to add to the drawing of the dog.

Step 4

I was happy with it overall, so I started to suggest the wavy hair, taking care not to get too caught up on the details. I darkened the area behind the ear, which emphasizes the rest of the drawing, bringing it into the foreground. I added the mid-tone to the hair, allowing the paper to shine through in places to create the highlights. After darkening the pupil of the eye with the pencil I added a white highlight with a pastel pencil to give it a nice sparkle. I put in a few darker lines here and there with my pencil and brush, then finished with a very light wash on the neck and shoulders.

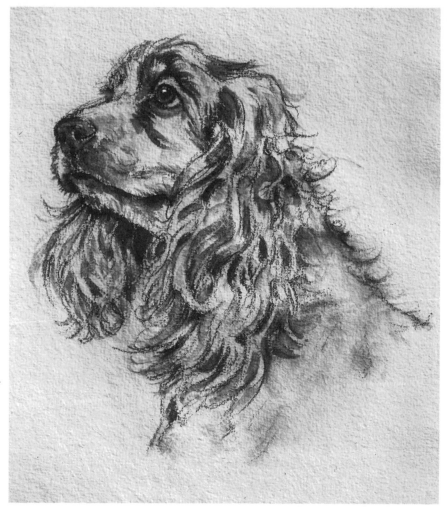

Cross Cat Step-by-Step

Marker pens are a great way to do quick sketches that look finished. Because of this, concept and storyboard artists all use markers to create their visuals.

Materials and Equipment

- 3B pencil
- Bleedproof marker pad
- Putty rubber
- Marker pens in light grey, mid grey, dark grey and black
- Blender pen
- White pastel pencil

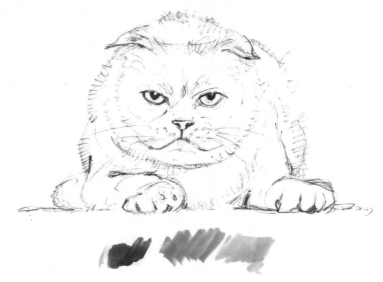

Step 1

First I drew the outline of this lovely fat cat with tiny ears and suggested where the tone would go. If you were working in concept art you would then photocopy this a few times so you could try different colour versions to show to the art director or costume designer. For our purposes we just need the one version, but bear in mind the possibility of doing this for future ideas.

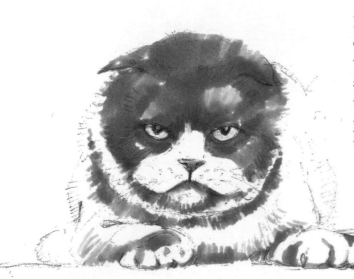

Step 2

Next, I added in my mid-tones on the cat's head using the mid-grey marker pen, at this stage keeping everything fairly loose. I worked around the top of the head and cheeks.

Tip Before you use marker pens on your drawing, try them out on a separate piece of paper. Practise blending the tones into each other and see what effects you can achieve. Have a go with the blender pen too; it's really useful and quite easy once you get the hang of it.

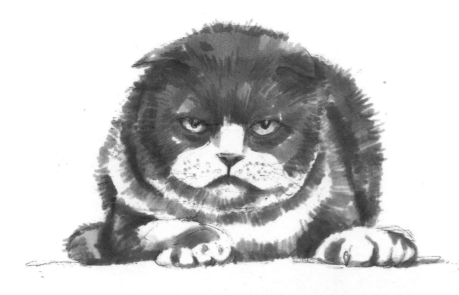

Step 3

Switching to my lightest tone of marker pen, I added shadows to the white of the cat's fur and paws, again keeping them fairly free and loose. With the blender pen, I mixed in between the tones to blend them before the marker lines were dry. I went over the eyes with a black marker and darkened the tone around them.

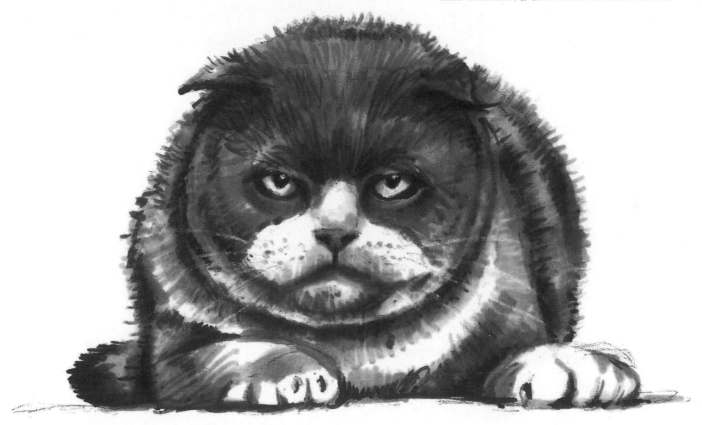

Step 4

I covered the rest of the cat with a mid-tone, then went over it to make it slightly darker and indicate the fur. I also used this tone to give shadow on the eyes. I started to use my dark grey marker pen to add the darkest tones on the face and body, blending the tones as I went. On the forehead, I used the blender pen almost like a layering wash of water then quickly added the hair with the dark pen. Finally, I added the highlight in the eyes with a white pastel pencil.

Miniature Schnauzer Step-by-Step

For some reason this dog reminds me of Gandalf from *The Lord of the Rings*. I guess it is because of the beard and the eyebrows! Drawing a characterful animal is always more fun.

Materials and Equipment

- Dark charcoal pencil
- Rough surface tinted paper
- Putty rubber
- Pencil sharpener

Step 1

I started with a detailed sketch and completed this fairly quickly.

Step 2

Trying to work fast as if the dog were in front of me and I had only a little time to catch his likeness, I concentrated on the ears and eyes.

Tip When you're doing a drawing such as this one, keep your pencil constantly sharpened to a point so that you always get those tight, clean, fine lines.

Step 3

I redrew the nose and altered the mouth area slightly, then defined the eyebrows and eyes more as I slowly worked my way down the drawing. I changed the jawline and started to draw the dog's mouth by following the contours of the hair turning in on the top lip. I also altered the angle of the left eye to make it fit the angle of the dog's head. I was working frantically now to try to keep the drawing fresh! I quickly put in the bottom of the beard without showing too much detail and suggested the tone of the neck showing in between the spaces in the beard. Finally, I tidied up the eyes, ears and nose.

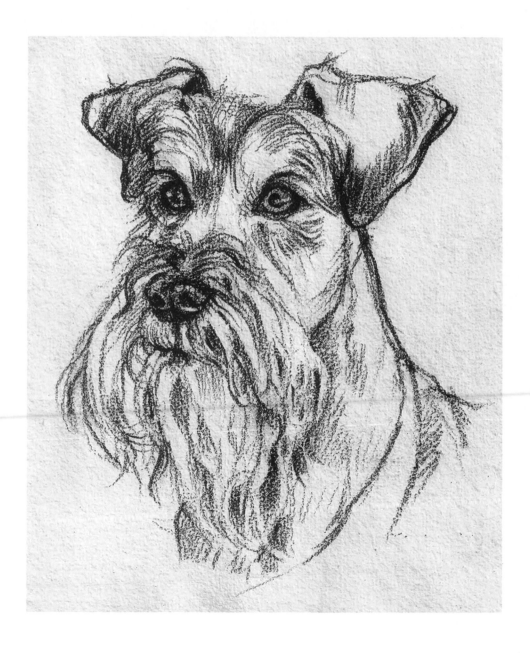

Afghan Hound Step-by-Step

This dog reminds me of a rock star, with the long hair and the sunken cheeks – yes, it's Iggy Pop!

Step 1

I sketched a quick outline with a white pastel pencil on the black paper, then added some white pastel to the face, spreading this over the whole facial area with the brush.

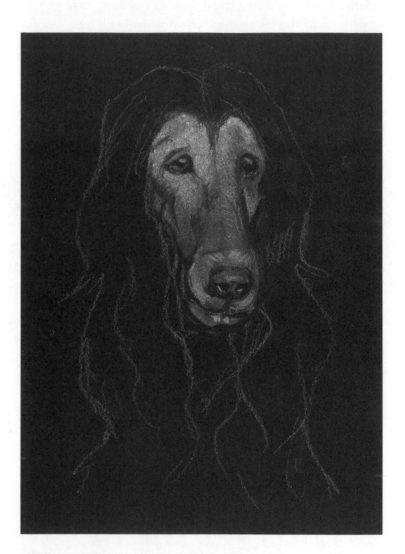

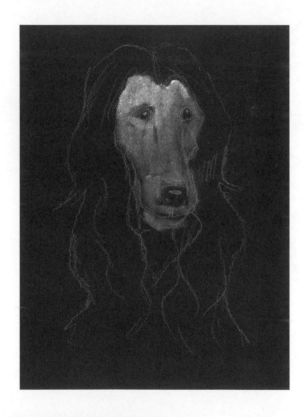

Materials and Equipment

- White pastel pencil
- Black Canford paper
- White, light grey and black pastel sticks
- Watercolour brush, No. 8 round
- Charcoal pencil
- Putty rubber

Step 2

Next, I went in with the charcoal pencil and redrew the eyes, as they looked a little odd. I redid the nose, adding a grey pastel to cover it, then charcoal pencil. I did the same around the cheeks and mouth and added some white highlights to the nose and lip with my white pastel pencil.

Composition and Pet Portraits

Step 3

I used the side of the white pastel to go around the edges of the head and then with a dry brush blended it all in to help the black hair stand out. I added some white pencil pastel lines where the highlights would be, then dusted the dry brush over the white surrounding the head. This picked up enough pastel dust to paint in the white highlights on the hair. Then I used the charcoal pencil to darken any areas to give me shapes and shadows and went over the whites of the hair to suggest the strands.

Taking a look at the reference picture, I could see that the face needed adjusting, so I widened the cheekbones and altered the eyes again. This time I made them larger and moved the one on the right slightly outwards by adding more white pastel and smoothing it out with a brush. Then I redrew the eye and socket with a charcoal pencil and white pastel pencil. Finally, I added some white whiskers and our rock star Afghan hound was done!

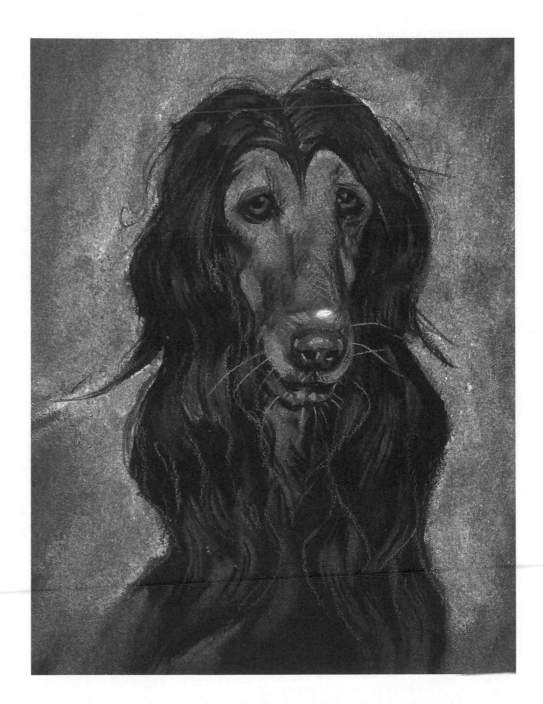

Tip Don't be afraid to mess up your drawing when you are using pastels. The beauty of this medium is that you can just smudge it out and redraw over it.

Siberian Cat Step-by-Step

In this drawing I wanted to catch that look of mischief that cats sometimes have; one minute they're all soft and playful, the next they're ready to strike.

Materials and Equipment

- 3B pencil
- Putty rubber
- 220gsm (100lb) cartridge paper
- Pencil sharpener
- Black brush pen
- Watercolour brush, No. 8 round

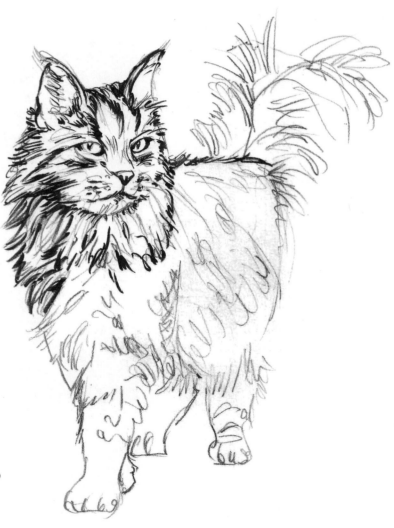

Step 1

I drew the cat, using a minimum of detail. I only needed to have a suggestion of where I would be adding the tone.

Step 2

Next I started inking in the cat's head with the brush pen, keeping the strokes light but controlled. Anticipating that I would be able to use a water wash to create the dark shadows and the tone of the cat's fur, I left a lot of white paper showing.

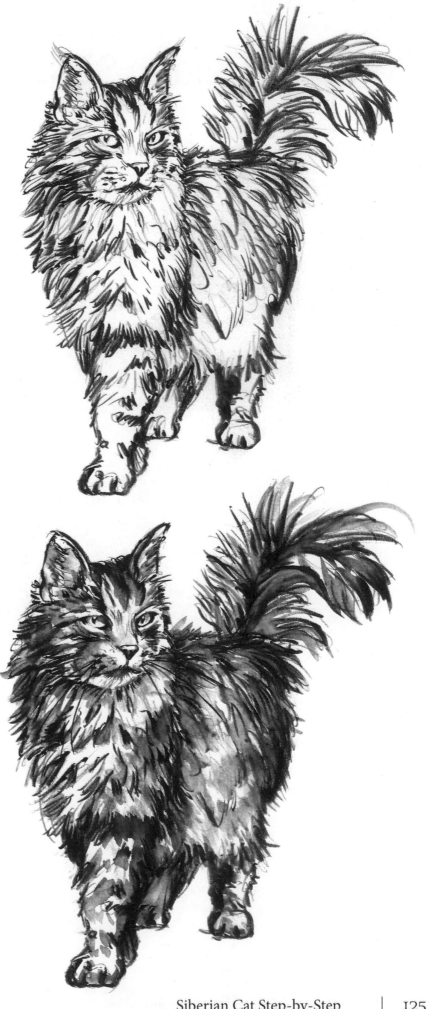

Step 3

Towards the end of the inking stage I used a brush pen that was running out, which gave me a paler, looser tone to play with for the back of the cat.

Step 4

I added water to my brush and painted into the inked areas, keeping control of the ink as it spread on the paper by guiding it to where I wanted it. I left the central area of the head free of the tone so that it is a point of focus. Working on the fur under the chin, I kept it dark on the left and light on the right to convey its texture. I concentrated mostly on the front of the coat, keeping this part more detailed.

Along the body towards the tail I let the washes of ink become paler and looser, trying to suggest an out-of-focus look. I washed the water over the tail and dabbed at it with my tissue to lift off any excess wash in order to prevent it from becoming too dark. Finally, I went back to the cat's eyes and added a shadow under the top lid as this helps them to feel more real.

Pony and Rider Step-by-Step

To finish off, here's a drawing of a pony and rider for you to have a go at. It looks a bit more complicated than the earlier drawings, but just keep basic shapes in mind and you won't go far wrong.

Materials and Equipment

- 8B Derwent watersoluble sketching pencil
- 220gsm (100lb) cartridge paper
- Pencil sharpener
- Putty rubber

Step 1

I started with my usual doodle to get the idea of what I was to draw. Using some circles and ovals I sketched the pony and girl, then checked my reference to see where the shadows fell and drew them in. After that I was ready to start on my drawing proper. Referring to my photograph and doodle, I began outlining the pony and rider, adding more tone in the shadow areas. I then paid close attention to the bridle, reins and saddle, as it was important to take my time and make sure the details were correct. Details like these help to give you visual clues to a drawing: for instance, the reins take you from the pony's mouth to the girl's hands, and from there the girl's finger leads you to the saddle; following the line down from that leads you to the boot and then to the stirrup and so on (see drawing on the left). You will find plenty of clues such as these in the subjects you draw if you look for them.

Step 2

Next I added more detail and tone and started working my way along the pony, emphasizing its form and the muscles in the neck, chest and front legs. I added more tone to the shadow, which helped to ground the pony on the page.

Step 3

I worked along the rest of the drawing, darkening the legs and underbelly of the pony to show shadow and indicate its three-dimensionality. When I had finished the pony I worked on the girl, darkening the shadows on her top and jodhpurs. While I was in that area I finished the straps and saddle. Then I put the final touches to her face and helmet, keeping the marks on her face to a minimum so that she looks fresh and childlike.

Pony and Rider Step-by-Step | 127

Index

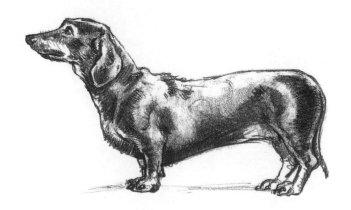